17.95
5.00

D1597540

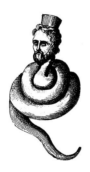

Fantastic Ornaments
Ornements fantastiques
Fantastische Ornamente
Фантастический Орнамент

Clara Schmidt

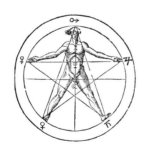

L'Aventurine

© PCM, Lyon, 2007
Russian: Julia Eveleva

Foreword

The taste for the fantastic takes its source in the Antique spirit and art. Weren't gorgons, cyclops and satyrs among the first fantastic elements of mythology and Antique art?

As early as the Renaissance, interest in the unreal and the marvelous revived, spurred on by archeological discoveries in Rome. Vasari expressed his enchantment as an impassioned amateur of the arts upon viewing the Loggias of the Vatican decorated by Raphaël, « Stucco work surrounded by beautiful ornaments of grotesques in the Antique style, filled with delightful fantasies and the most diverse and extravagant things that one can imagine «. The art of the grotesque comes into being, with its demons, monsters and composite creatures - half human, half-animal - gorgons, masks and sirens suspended in the midst of architectural decors.

At the same time monsters straight from the imagination of an Albrecht Dürer, faithful to the Gothic tradition, a Hieronymous Bosch or a Brueghel were disseminated throughout northern Europe. Originally part of Christian iconography, devils and angels - be they guardians or maleficent - constitute the fantastical repertory of the Northern art, to which were added the mad and still others damned to Hell.

Magic, alchemy and sorcellery complete the darker side of this imagery.

In the 18th century, a theatrical style developed with its multitude of ornaments rivaling in the diversity and the strangeness of the forms. The cult of the bizarre came into itself in the auricular style, characterized by swirling, zoomorphic forms.

Finally, another completely different type of fantastique was created in the 19th century by artists such as Gustave Doré and Grandville who animated animals and cultivated a Rabelaisian world.

This encyclopedia brings together for your viewing pleasure strange, astonishing, amusing and suggestive images.

Avant-propos

Le goût du fantastique prend sa source dans l'esprit et l'art antiques. Les gorgones, cyclopes et autres satyres ne figurent-ils pas les premiers éléments fantastiques de la mythologie et de l'art antique ?

Dès la Renaissance, cet attrait pour l'irréel et le merveilleux reprend vie, attisé par les découvertes archéologiques romaines. Vasari exprime l'enchantement éprouvé par l'amateur passionné à la vue des Loges du Vatican décorées par Raphaël : « Stucs entourés de beaux ornements de grotesques à l'antique, pleins de ravissantes fantaisies et des choses les plus diverses et extravagantes que l'on puisse imaginer. » L'art de la grotesque est né, avec ses démons, ses monstres, ses êtres composites étranges – ni tout à fait animaux, ni tout à fait humains – ses gorgones, ses masques et ses sirènes flottant au milieu d'architectures organiques.

Dans le même temps, ce sont les monstres tout droits sortis de l'esprit d'un Dürer, fidèle à la tradition gothique, d'un Jérôme Bosch ou d'un Brueghel qui se répandent au Nord de l'Europe. Les diables, les anges – qu'ils soient gardiens ou maléfiques – toute une icônographie chrétienne au premier chef constituent le premier répertoire fantastique de cet art nordique, auquel viendront s'ajouter quelques fous et autres damnés de l'Enfer.

L'envers du décor sera constitué par la magie, l'alchimie, la sorcellerie.

Plus tard, au XVIIIᵉ siècle, un style théâtral s'épanouira, dans lequel la pléthore des ornement viendra s'ajouter à la richesse et à la bizarrerie des formes. Ce culte du bizarre s'installera dans le style auriculaire, caractérisé par des formes tourbillonnantes et zoomorphiques.

Enfin, la plus grande fantaisie est apportée au XIXᵉ siècle, dans un tout autre registre, par des artistes tels que Doré ou Granville, qui cultiveront un univers rabelaisien et qui feront parler les animaux.

Ce livre vous propose un choix de figures étranges, étonnantes, amusantes, sulfureuses…

Vorwort

Der Sinn das Fantastische geht auf den Geist und die Kunst der Antike zurück. Sind doch die Riesen, Cyclopen und anderen Satyre die ersten wahren fantastischen Wesen des Mythologie und antiken Kunst.

Seit der Renaissance hat die Anziehungskraft für das Irreale und Wunderbare Gestalt angenommen, verstärkt noch durch die Entdeckungen der römischen Archäologen. Vasari drückt seine Begeisterung treffend aus angesichts der von Raphael ausgemalten Logen des Vatikan : « Von schönen Ornamenten und Grotesken der Antike umwobene Stukkaturen, voller entzückender Fantasien und der Groteske ist geboren, mit ihren Dämonen, ihren Monstern, diesen fremdartigen Wesen – weder Tier noch mensch – diesen gehörnten Masken und dieser in Pflanzenwelten schwimmenden Sirenen.

Gleichzeitig breiten sich in Nordeuropa die dem gotischen Geist entsprungenen monster eines Dürers aus, die Geisteskinder eines Hieronimus Bosch oder die wilden Figuren eines Bruegel. Die Teufel, die Engel – seien sie nun Wächter oder Übeltäter – sie alle bilden einen weiten christlichen Biderbogen, den ersten Katalog dieser nordischen Kunst, dem sich noch einige Verrückte und andere Verdammte der Hölle anschließen.

Das dekorative Universum wird umrahmt von der Magie, der Alchemie, der Hexerei.

Später im 18ten Jahrhundert breitet sich ein mehr theatralischer Stil aus, in dem sich der Überfluß der Motive mit dem Reichtum der Formen und dem Bizarren mischt. Der Kult des Bizarren findet sich in beunruhigenden tierischen und Glieder mischenden Formen wieder.

der Höhepunkt des Fantastischen wird schließlich im 19ten Jahrhundert erreicht, mit ganz anderen neuen Formen von Künstlern wie Doré oder Granville, die ein Rabelais'sches Universum mit sprechenden Tieren kultivieren.

Im vorliegenden Werk bieten wir Ihnen eine reiche Auswhl an fremdartigen Figuren, erstaunlichen, amüsanten, überraschenden, gruseligen Gestalten.

Предисловие

Пристрастие к фантастическим эффектам берет свое начало в духе и искусстве античных времен. Горгоны, циклопы и сатиры были первыми фантастическими существами античного искусства и мифологии.

В эпоху Ренессанса возродился интерес к воображаемому и сверхъестественному, который подогревался археологическими открытиями в Риме. Страстный любитель искусства Вазари выражал свое восхищение при виде Лоджий Ватикана с росписями Рафаэля, «гипсовых изваяний, окруженных живописными орнаментами гротесков в античном стиле, с их непередаваемыми фантазиями и изобилием разнообразных, не поддающихся описанию вещей». Зарождается искусство гротеска с его демонами, чудовищами и нереальными существами – полулюдьми, полуживотными – горгонами, масками и сиренами в самом центре архитектурного декора.

В тот же период чудовища, созданные фантазией Альбрехта Дюрера, верного традициям готического стиля, Иеронима Босха и Брейгеля, стали встречаться и в работах мастеров Северной Европы. Изначально некая часть христианской иконографии, дьяволы и ангелы – будь то ангелы-хранители или злые духи – появлялись в фантастических работах мастеров стран Северной Европы, к которым также можно было причислить безумцев и проклятых, осужденных гореть в аду.

Магия, алхимия и колдовство завершают темную сторону этих образов.

В 18-м веке стал развиваться театральный стиль с его многочисленными разнообразными орнаментами, необычными по своей форме. Культ сверхъестественного проявился в «тайном» стиле с его завихряющимися, зооморфными формами.

И, наконец, еще один совершенно иной причудливый стиль был создан в 19-м веке такими художниками, как Гюстав Дорэ и Гранвилль, которые одушевляли животных и культивировали мир Франсуа Рабле.

Данная энциклопедия предлагает вашему вниманию изображения, одновременно необычные, удивительные, занимательные и заставляющие задуматься.

- Illustrations •
• Illustrationen •
• Иллюстрации •

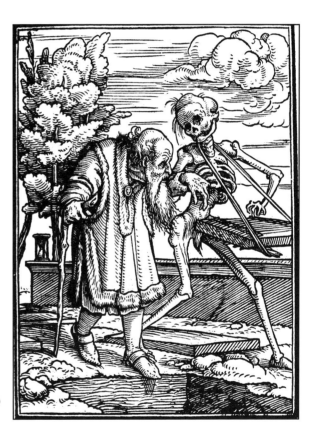

9

The Old Man, 16th century.
Le Vieillard, XVIᵉ siècle.
Der Greis, 16. Jahrh.
Старик, 16 век.

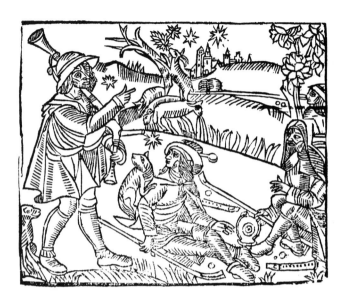

10-1

10-2

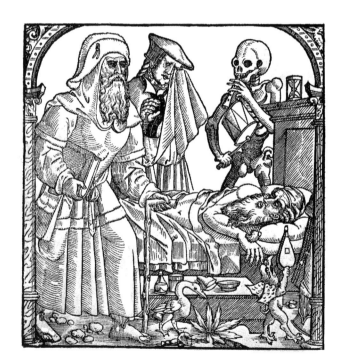

Typographic vignettes, 16th century.
Vignettes typographiques, XVIᵉ siècle.
Typographische Vignetten, 16. Jahrh.
Типографские виньетки, 16 век.

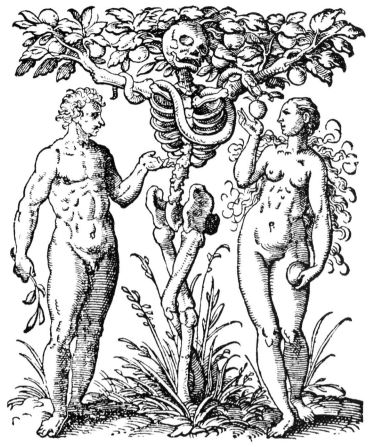

11-1

11-2

Typographic vignettes, 19th century.
Vignettes typographiques, XIXᵉ siècle.
Typographische Vignetten, 19. Jahrh.
Типографские виньетки, 19 век.

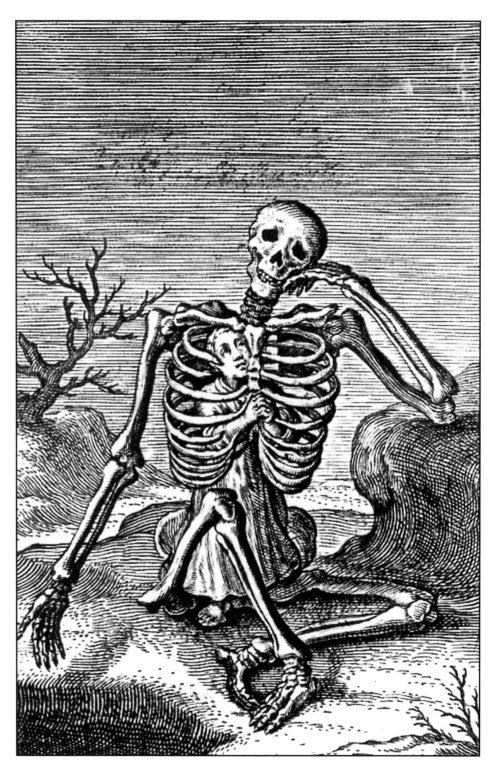

Pia Desideria. *Hermann Hugo,* Antwerpen, 1659.

12

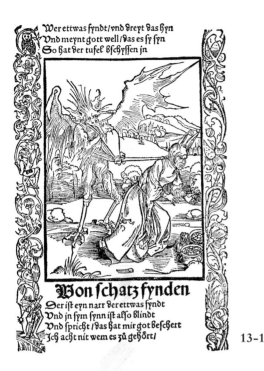

Wer ettwas fyndt / vnd greyt das hyn
Vnd meynt gott well / das es sy syn
So hat der tufel bscheyssen jn

Von schatz fynden

Der ist eyn narr der ettwas fyndt
Vnd jn fym fynn ist affo blindt
Vnd fpricht / das hat mir got befchert
Ich acht nit wem es zů gehört /

13-1

Albrecht Dürer. *The Dishonest Fool Finding a Treasure,* in Sebastian Brant, *The Ship of Fools,* Basel, 1494.
Albrecht Dürer. *Fou malhonnête trouvant des trésors,* in : Sebastian Brant. *La Nef des Fous,* Bâle, 1494.
Albrecht Dürer. *Ein unredlicher Narr findet Schätze,* aus: Sebastian Brant. *Das Narrenschiff,* Basel, 1494.
Альбрехт Дюрер. Бесчестный дурак в поисках сокровища, в кн. Себастьяна Бранта «Корабль дураков», Базель, 1494.

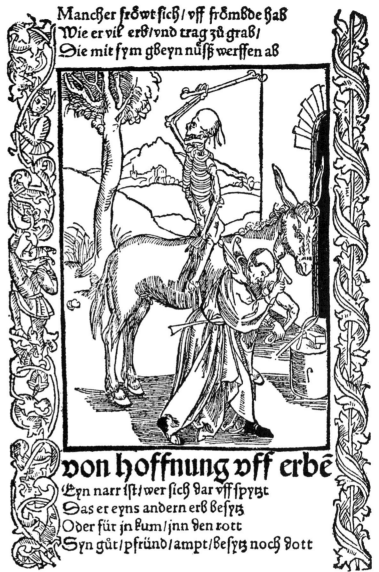

Mancher fröwt sich / vff frömbde haß
Wie er vil erb / vnd trag zů grab /
Die mit fym gbeyn nůß werffen aß

von hoffnung vff erbê

Eyn narr ist / wer sich dar vff fpytzt
Das er eyns andern erb befytz
Oder für jn kum / jnn den rott
Syn gůt / pfründ / ampt / befytz noch got

13-2

Albrecht Dürer. *The Blacksmith Fool,* in Sebastian Brant, *The Ship of Fools,* Basel, 1494.
Albrecht Dürer. *Fou forgeron,* in : Sebastian Brant. *La Nef des Fous,* Bâle, 1494.
Albrecht Dürer. *Narrenschmied,* aus: Sebastian Brant. *Das Narrenschiff,* Basel, 1494.
Альбрехт Дюрер. Глупый кузнец, в кн. Себастьяна Бранта «Корабль дураков», Basel, 1494.

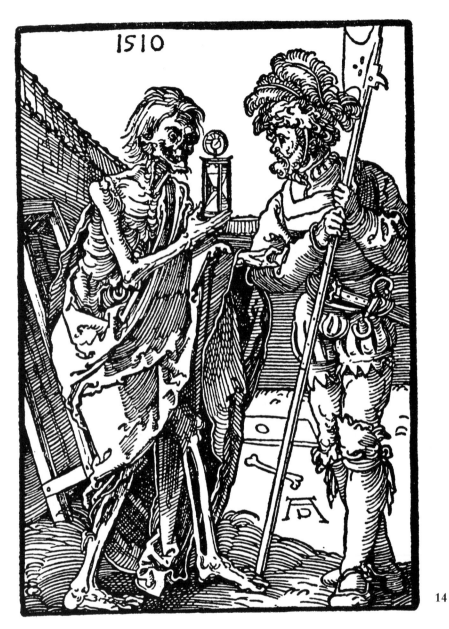

14

Albrecht Dürer. Death and the Lansquenet, Basel, 1510.
Albrecht Dürer. La Mort et le lansquenet, Bâle, 1510.
Albrecht Dürer. Der Tod und der Landsknecht, Basel, 1510.
Альбрехт Дюрер. Рыцарь и смерть, Базель, 1510.

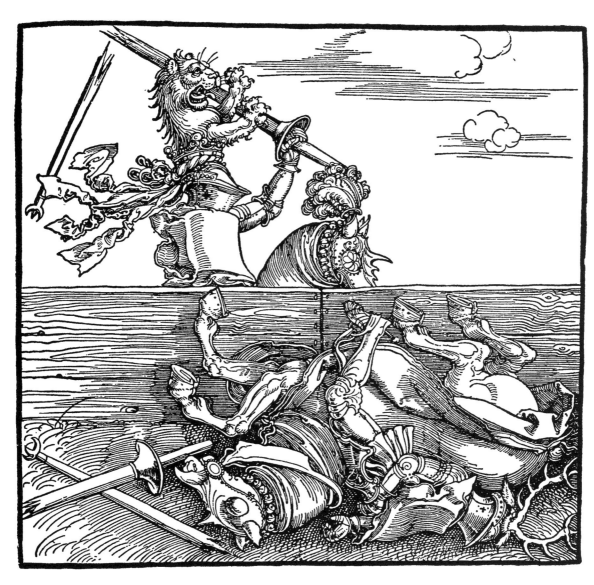

Albrecht Dürer. The French Tournament, nd.
Albrecht Dürer. Le Tournoi français, s.d.
Albrecht Dürer. Das französische Turnier, undatiert.
Альбрехт Дюрер. Французский турнир.

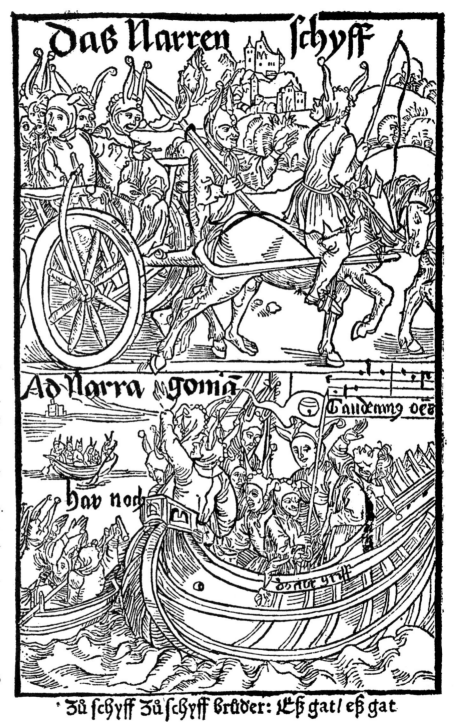

Albrecht Dürer. *Title page, in* Sebastian Brant, *The Ship of Fools*, Basel, 1494. Albrecht Dürer. *Page de titre, in :* Sebastian Brant. *La Nef des Fous*, Bâle, 1494. Albrecht Dürer. *Titelseite, aus:* Sebastian Brant. *Das Narrenschiff*, Basel, 1494. Альбрехт Дюрер. Титульный лист в кн. Себастьяна Бранта «Корабль дураков», Базель, 1494.

Wer singt Cras Cras glich wie eyn rapp
Der blibt eyn narr biß jnn syn grapp
Morn hat er noch eyn grösser kapp

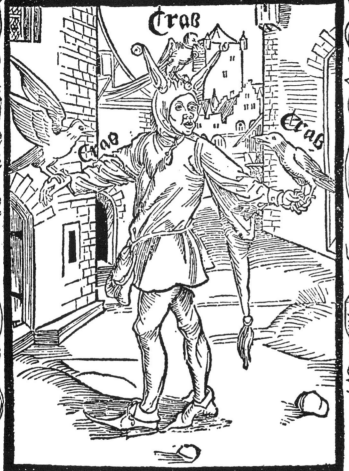

Von vffschlag suche
Der ist eyn narr dem gott jn gyt
Das er sich besseren soll noch hüt
Vnd soll von synen sünden lan
Eyn besser leben voßen an

Albrecht Dürer. *Fou incorrigible,* in : Sebastian Brant. *La Nef des Fous,* Bâle, 1494.
Albrecht Dürer. *Unverbesserlicher Narr,* aus: Sebastian Brant. *Das Narrenschiff,* Basel, 1494.
Альбрехт Дюрер. Неисправимый дурак, в кн. Себастьяна Бранта «Корабль дураков», Базель, 1494.

17

Manchen dunckt/er wer witzig gern
Vnd ist eyn ganß doch/hür als vern
Dann er keyn zücht/vernunfft/will lern

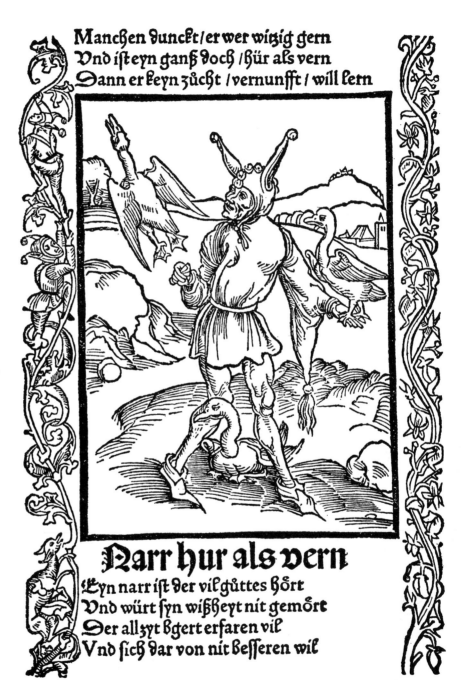

Albrecht Dürer. *The Fool with Geese*, in Sebastian Brant, *The Ship of Fools*, Basel, 1494.
Albrecht Dürer. *Fou aux oies*, in : Sebastian Brant. *La Nef des Fous*, Bâle, 1494.
Albrecht Dürer. *Der Narr und die Gänse*, aus: Sebastian Brant. *Das Narrenschiff*, Basel, 1494.
Альбрехт Дюрер. Дурак с гусями, в кн. Себастьяна Бранта «Корабль дураков», Базель, 1494.

Narr hur als vern

Eyn narr ist der vil güttes hört
Vnd würt syn wißheyt nit gemört
Der allzyt bgert erfaren vil
Vnd sich dar von nit besseren wil

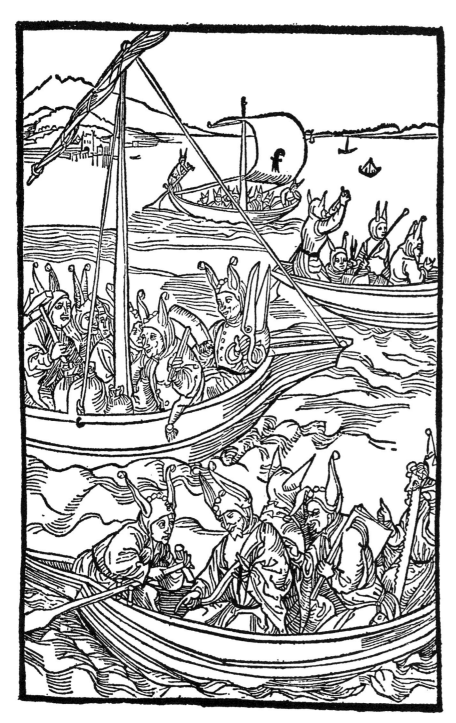

Albrecht Dürer. *The Travelling Fools,* in Sebastian Brant, *The Ship of Fools,* Basel, 1494.

Albrecht Dürer. *Fous en voyage,* in : Sebastian Brant. *La Nef des Fous,* Bâle, 1494.

Albrecht Dürer. *Narren auf Reise,* aus: Sebastian Brant. *Das Narrenschiff,* Basel, 1494.

Альбрехт Дюрер. Дураки-путешественники, в кн. Себастьяна Бранта «Корабль дураков», Базель, 1494.

19

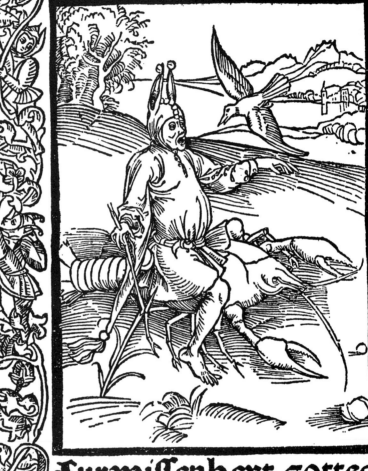

Wer on verdienſt / will han den lon
Vnd vff eym ſchwachen ror will ſton
Des anſchlag / wurt vff krebſen gon

Albrecht Dürer. *The Fool riding a crawfish,* in Sebastian Brant, *The Ship of Fools,* Basel, 1494.
Albrecht Dürer. *Fou chevauchant l'écrevisse,* in : Sebastian Brant. *La Nef des Fous,* Bâle, 1494.
Albrecht Dürer. *Der Narr reitet den Krebs,* aus: Sebastian Brant. *Das Narrenschiff,* Basel, 1494.
Альбрехт Дюрер. Дурак верхом на раке, в кн. Себастьяна Бранта «Корабль дураков», Базель, 1494.

Furwiſſenheyt gottes
Man fyndt gar manchen narren ouch
Der ferßet vß der gſchrifft den gouch
Vnd dunckt ſich ſtryffecht vnd gelert
So er die bücher hat vmb kert

20

Eyn zeichen der liechtferikeyt
Jst /glouben was eyn yeder seit
Eyn Rlapperer bald vil lüt vertreit

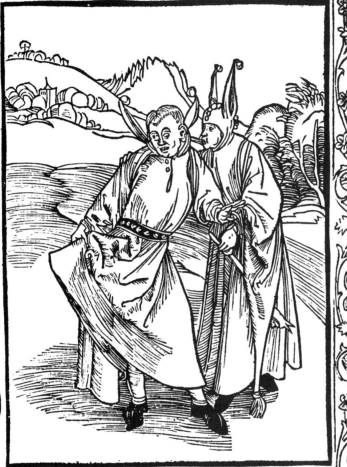

Von oren blofen.
Der ist eyn narr /der vaßt jnns houbt
Vnd lichtlich yedes schwätzen gloubt
Das ist eyn anzeig zů eym toren
Wann eyner dünn /vnd witt /hat oren

Albrecht Dürer. The
Murmurring Fools, in
Sebastian Brant, *The Ship of
Fools,* Basel, 1494.
Albrecht Dürer. *Fous mur-
murant,* in : Sebastian Brant.
La Nef des Fous, Bâle, 1494.
Albrecht Dürer. *Murmelnder
Narr,* aus: Sebastian Brant.
Das Narrenschiff, Basel,
1494.
Альбрехт Дюрер.
Шепот дураков, в кн.
Себастьяна Бранта
«Корабль дураков»,
Базель, 1494.

21

The Calendar of the Shepherds, 1497.
Le Calendrier des bergers, 1497.
Der Schäfers Kalender, 1497.
Пастуший календарь, 1497.

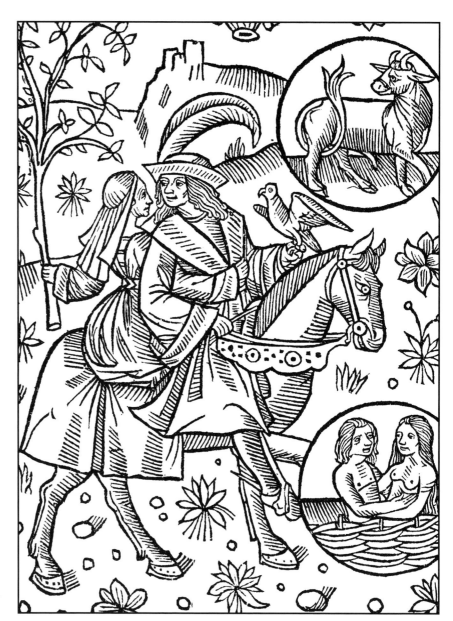

22

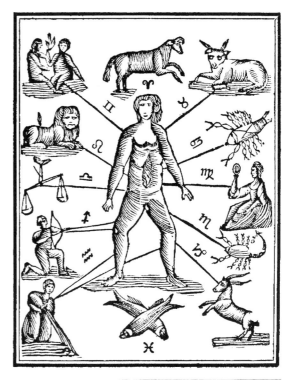

23-1

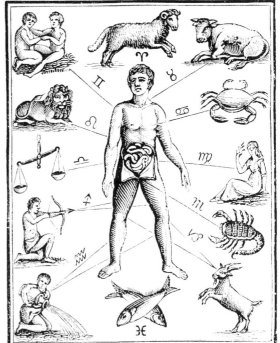

Typographic Vignettes, 19th century.
Vignettes typographiques, XIXᵉ siècle.
Typographische Vignetten, 19. Jahrh.
Типографские виньетки, 19 век.

23-2

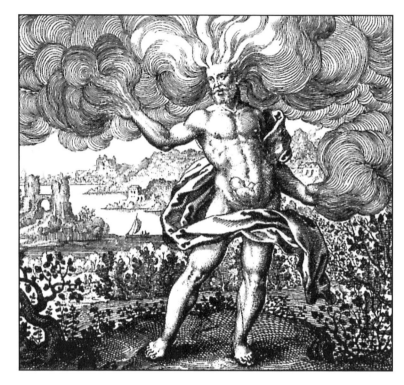

24-1

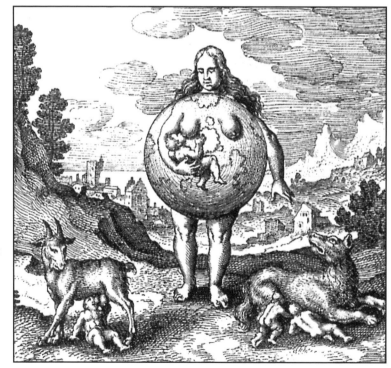

Michel Maier. *Atalanta fugiens*, 1618.

24-2

24

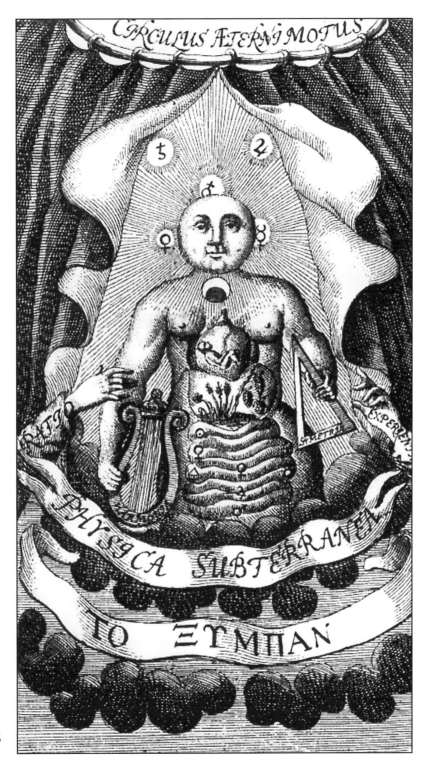

J.J. Becher. *Physica Subterranea*, 1703.

25

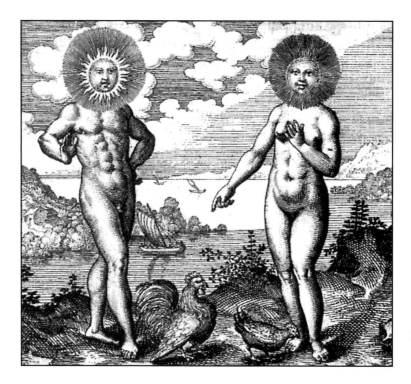

26-1

Stolcius von Stolcenberg.
Viridarium chymicum,
Frankfurt, 1624.

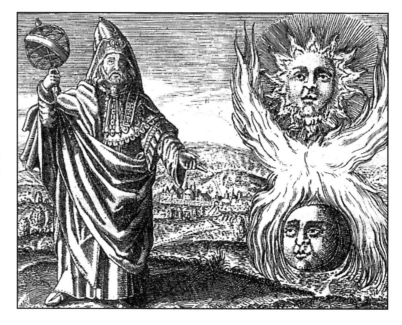

26-2

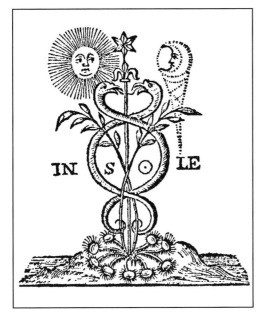

27-1

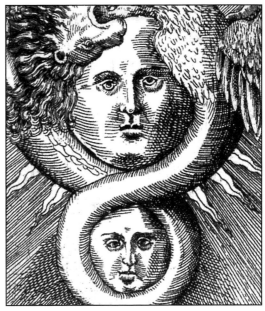

27-2

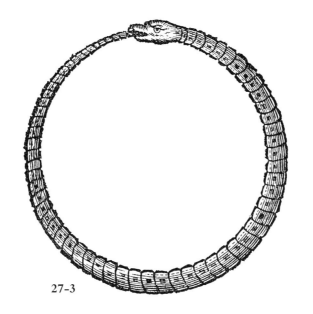

27-3

27-1:
Vignette, 18th century.
Vignette, XVIIIᵉ siècle.
Vignette, 18. Jahrh.
Виньетка, 18 век.

27-2:
 Stolcenberg. *Viridarium chymicum,* Frankfurt, 1624.

27-3:
Vignette, 17th century.
Vignette, XVIIᵉ siècle.
Vignette, 17. Jahrh.
Виньетка, 17 век.

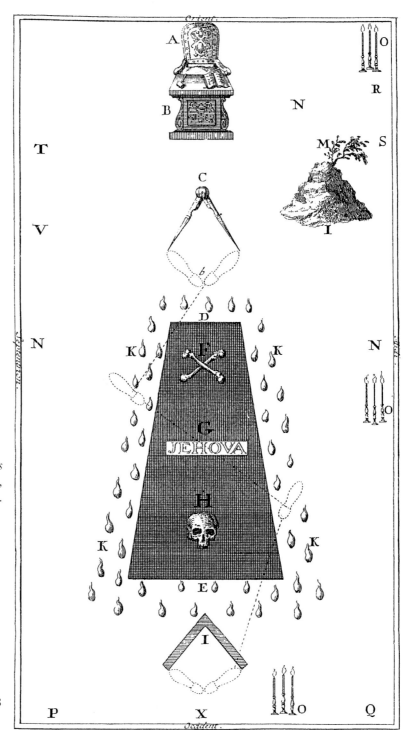

L'Ordre des Francs-maçons trahi…, Amsterdam, 1745.

Vivat 1801.

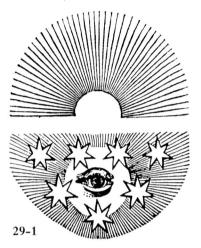

29-1

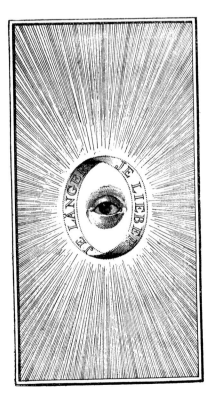

29-2

29-1:
Typographic vignette, 19th century.
Vignette typographique, XIX^e siècle.
Typographische Vignetten, 19. Jahrh.
Типографские виньетки,
19 век.

29-2:
Seraphinisch Blumengärtlein,
18th century.
Seraphinisch Blumengärtlein,
XVIII^e siècle.
Seraphinisch Blumengärtlein, 18. Jahrh.
Seraphinisch Blumengärtlein, 18 век.

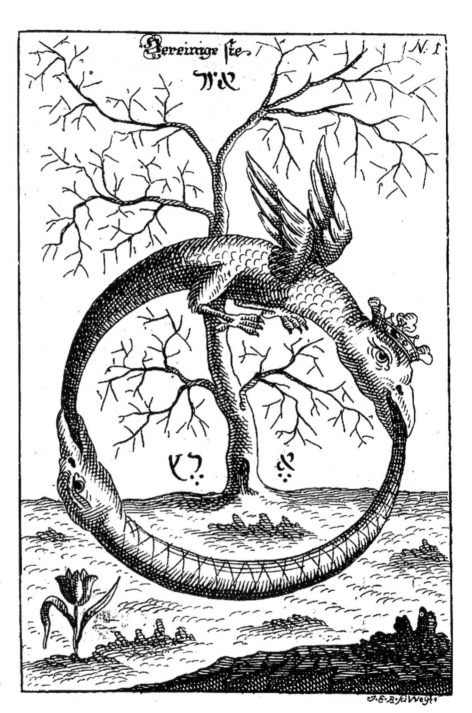

Abraham Eléazar. *Uraltes Chymisches Werk*, Leipzig, 1760.

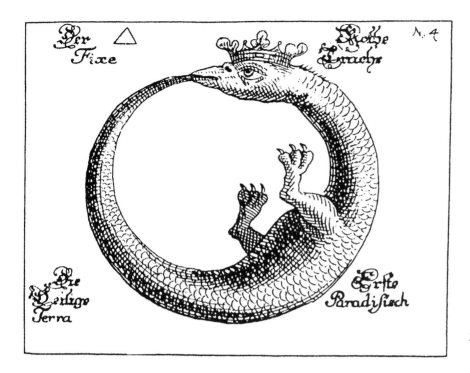

31-1

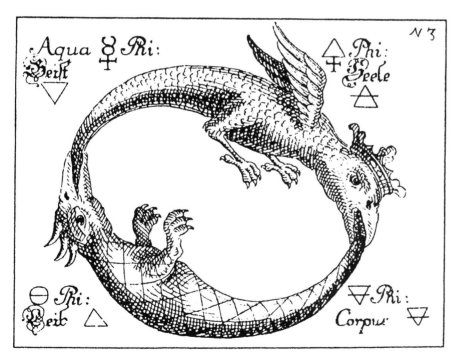

Abraham Eléazar. *Donum Dei,*
Erfurt, 1735.

31-2

31

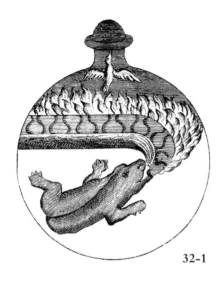

32-1

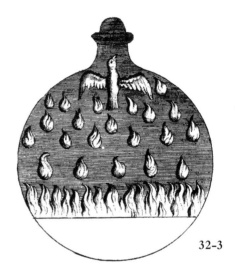

32-3

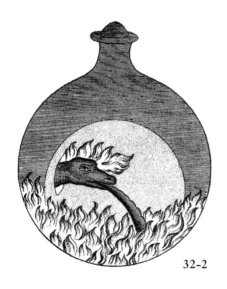

32-2

Barckhausen. *Elementa Chymiae,*
Leyden, 1718.

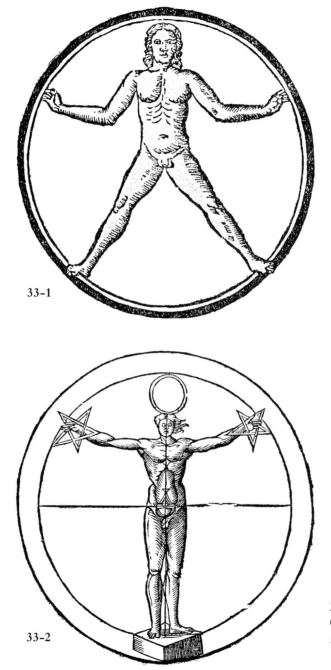

33-1

33-2

33-35:
Cornelius Agrippa. *De Occulta Philosophia*, 1533.

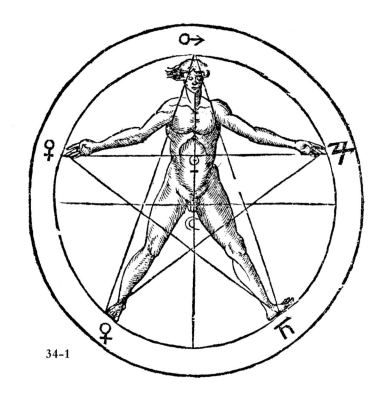

34-1

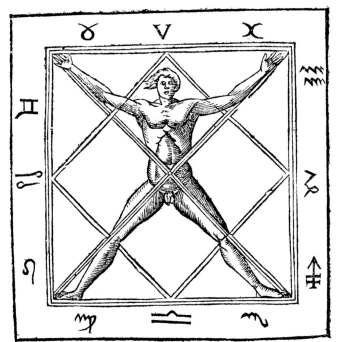

34-2

34

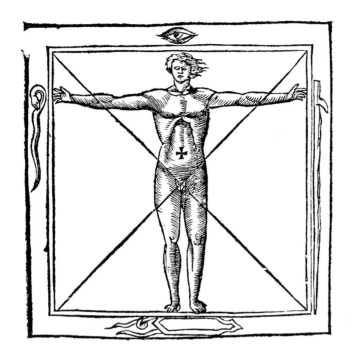

35-1

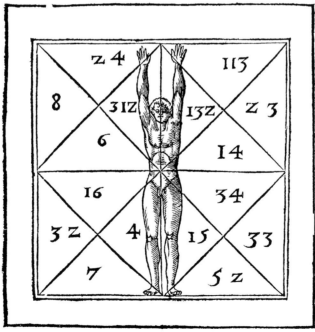

35-2

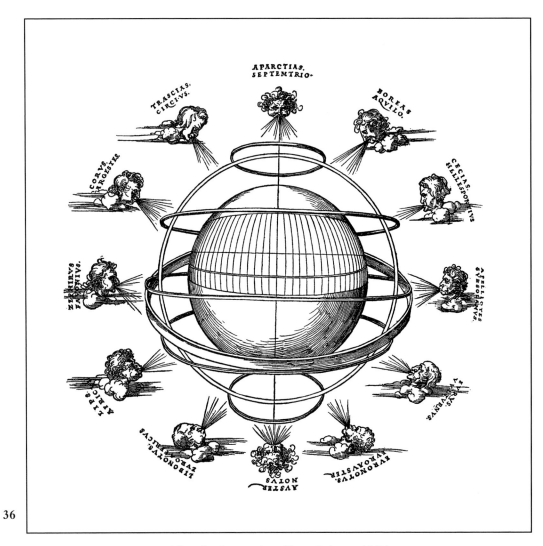

Albrecht Dürer. Armillary Sphere, 1515.
Albrecht Dürer. Sphère armillaire, 1515.
Albrecht Dürer. Armillarsphäre, 1515.
Альбрехт Дюрер. Армиллярная сфера (астр. прибор), 1515.

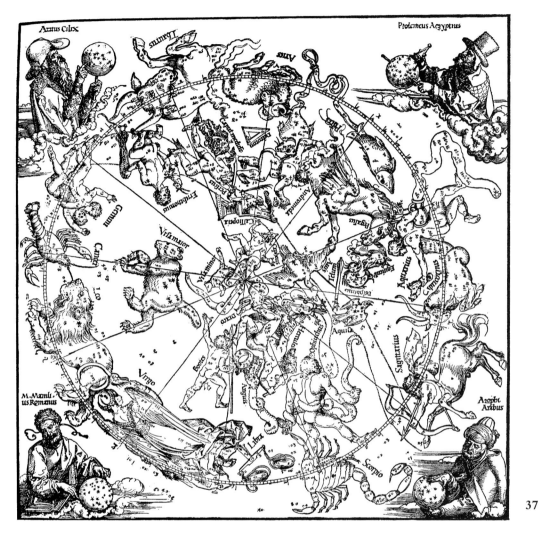

Albrecht Dürer. Celestial Globe, North face, 1515.
Albrecht Dürer. Le Globe céleste, face nord, 1515.
Albrecht Dürer. Himmelsglobus, Nordseite, 1515.
Альбрехт Дюрер. Глобус звездного неба, Северное полушарие, 1515.

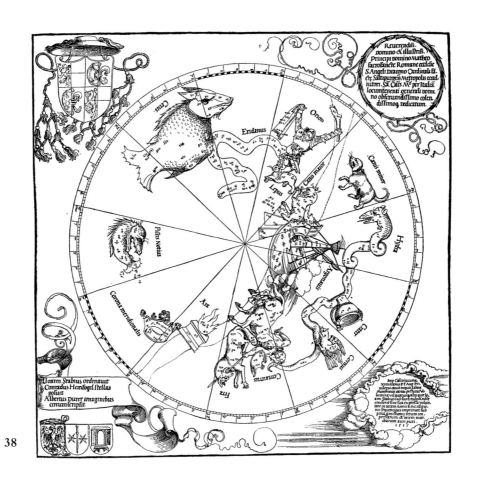

38

Albrecht Dürer. Celestial Globe, South face, 1515.
Albrecht Dürer. Le Globe céleste, face sud, 1515.
Albrecht Dürer. Himmelsglobus, Sudseite, 1515.
Альбрехт Дюрер. Глобус звездного неба, Южное полушарие, 1515.

39-2

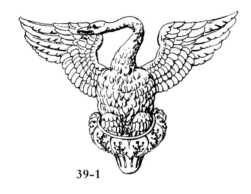

39-1

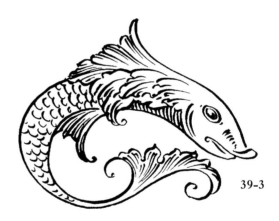

39-3

39-41:
Typographic Vignettes, 19th century.
Vignettes typographiques, XIXᵉ siècle.
Typographische vignetten , 19. Jahrh.
Типографские виньетки, 19 век.

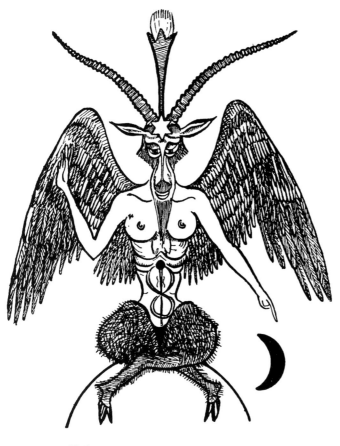

40-1

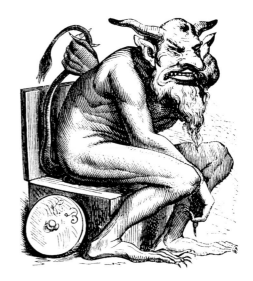

40-2

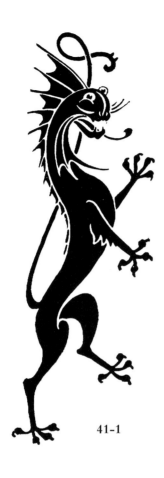

41-1

41-2

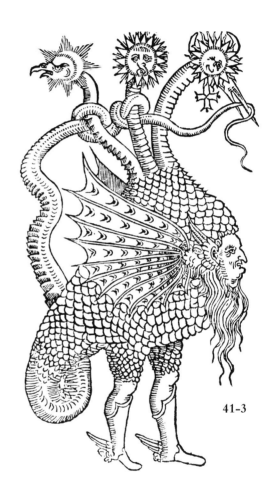

41-3

42-44:
Illustrations, in J.G. Heck. *The Complete Encyclopedia of Illustration, London,* 1851.
Illustrations, in : J.G. Heck. *The Complete Encyclopedia of Illustration,* Londres, 1851.
Illustrationen, aus: J.G. Heck. *The Complete Encyclopedia of Illustration,* London, 1851.
Иллюстрации, в кн. J.G. Heck. *The Complete Encyclopedia of Illustration,* London, 1851.

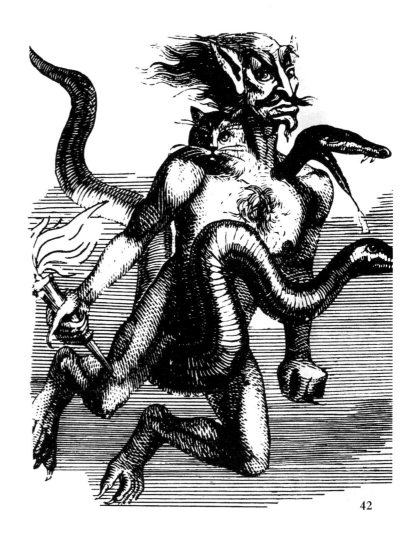

42

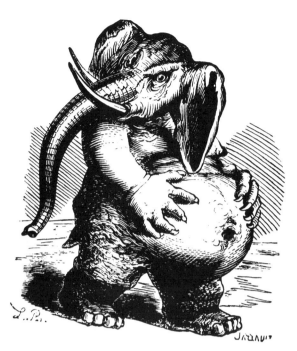

43-1

43-2

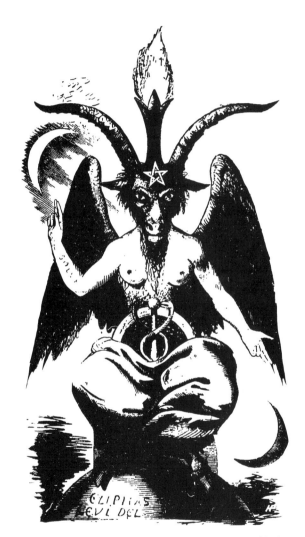

43-3

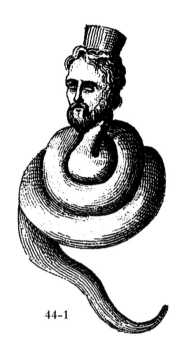

44-1

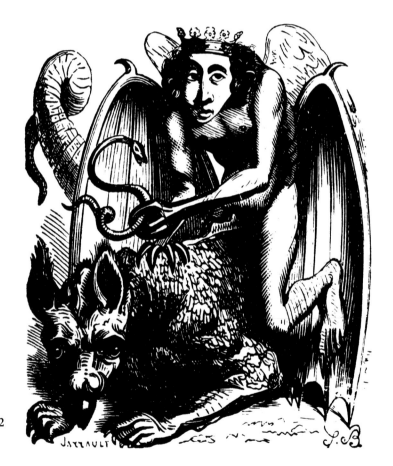

44-2

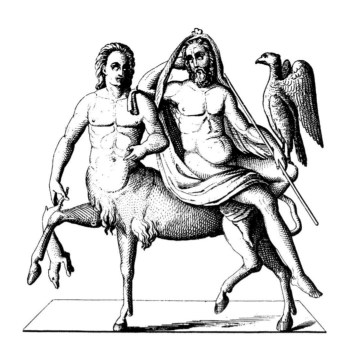

45-1

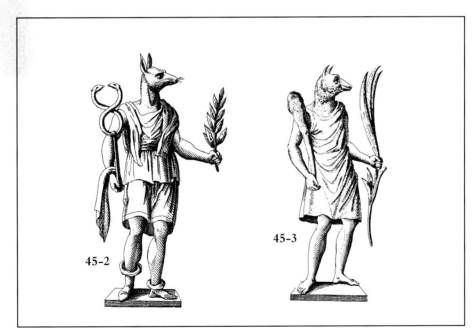

45-2

45-3

Recueil des dessins d'ornements
d'architecture de la Manufacture de Joseph Beugnat, circa 1813.

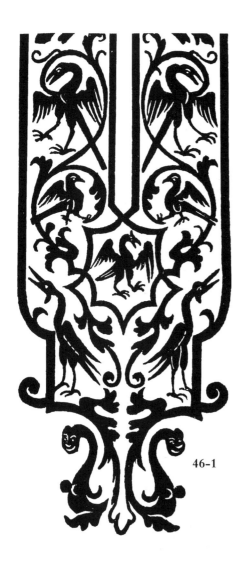

46-1

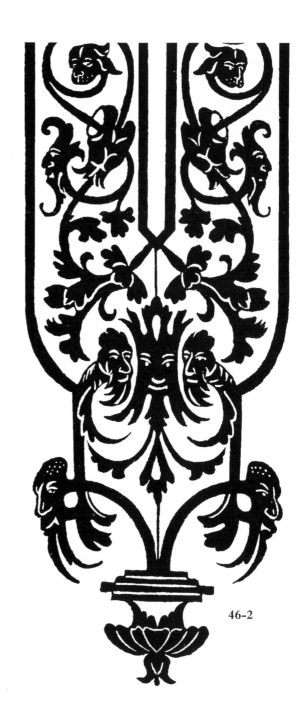

46-2

Alessandro Paganino, Lace designs, Venice, 1518.
Alessandro Paganino, Motifs de dentelle, Venise, 1518.
Alessandro Paganino, Spitzenmotive, Venedig, 1518.
Алессандро Паганино, Ажурные узоры, Венеция, 1518.

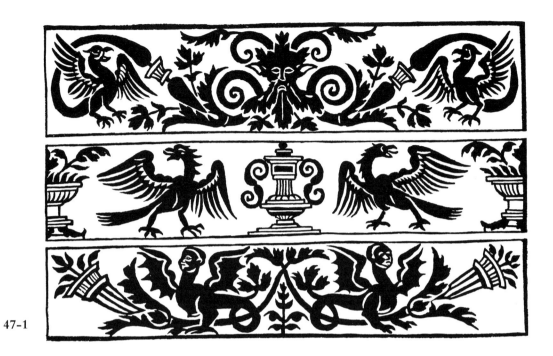

47-1

47-2

47-3

Peter Quentel.
Embroidery designs,
Köln, 1532.

Peter Quentel.
Motifs de broderie,
Köln, 1532.

Peter Quentel.
Stickmotive, Köln,
1532.

Петер
Квентель.
Образцы
вышивки,
Кельн, 1532.

48-1

48-2

48-3

48-4

48-5

Borders in the
Renaissance style, 19th
century.
Bordures de style
Renaissance,
XIXᵉ siècle.
Bordüren im
Renaissance-Stil,
19. Jahrh.
Фризы в стиле
Ренессанс, 19 век.

48-6

48-7

49-1

49-2

49-3

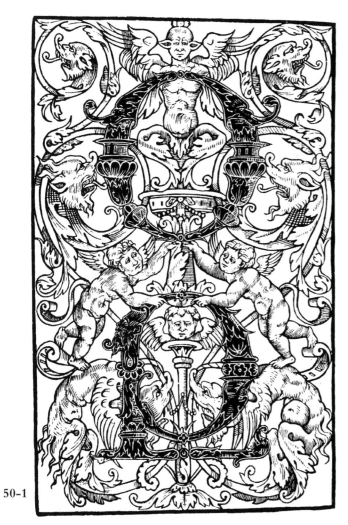

50-1

Juan de Yciar. Initials, 1550.
Juan de Yciar. Initiales, 1550.
Juan de Yciar. Initialen, 1550.
Хуан де Исиар. Инициалы, 1550.

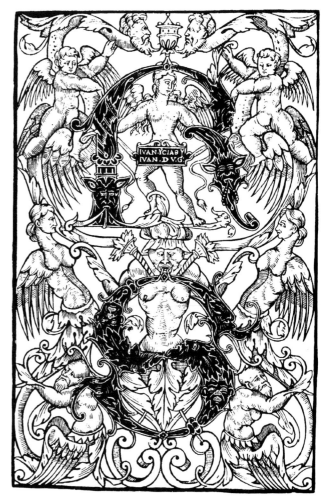

50-2

Peter Quentel.
Embroidery designs,
Köln, 1532.

Peter Quentel. Motifs
de broderie, Köln,
1532.

Peter Quentel.
Stickmotive, Köln,
1532.

Петер Квентель.
Образцы вышивки,
Кельн, 1532.

51

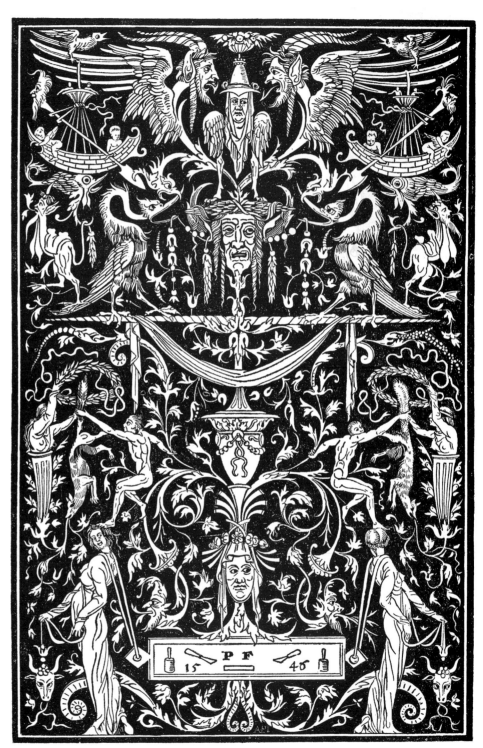

Peter Flöttner. Designs for metal engravings, Zürich, 1546.
Peter Flöttner. Motifs de gravure sur métal, Zürich, 1546.
Peter Flöttner. Metallstichmotive, Zürich, 1546.
Петер Флетнер. Рисунки для гравюр по металлу, Цюрих, 1546.

52

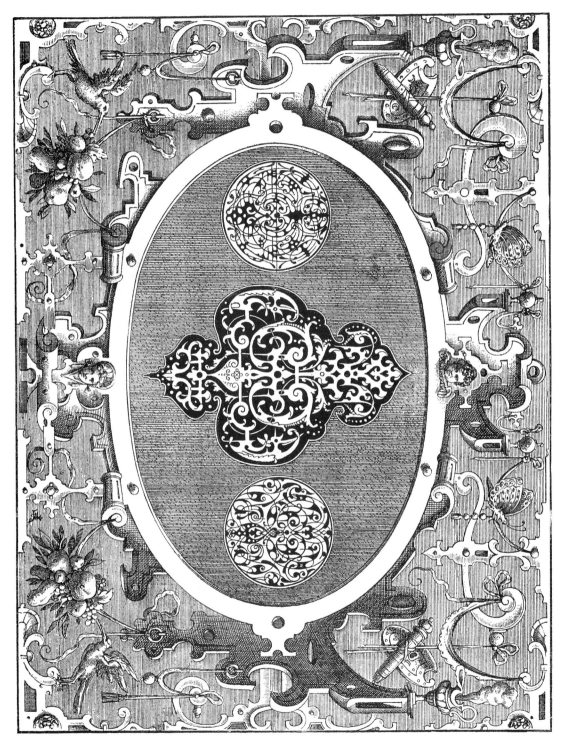

Entourage, The
Netherlands,
16th century.
Entourage, Pays-
Bas, XVIᵉ siècle.
Umgebung,
Niederlande, 16. Jh.
Антураж,
Нидерланды,
16 век.

53

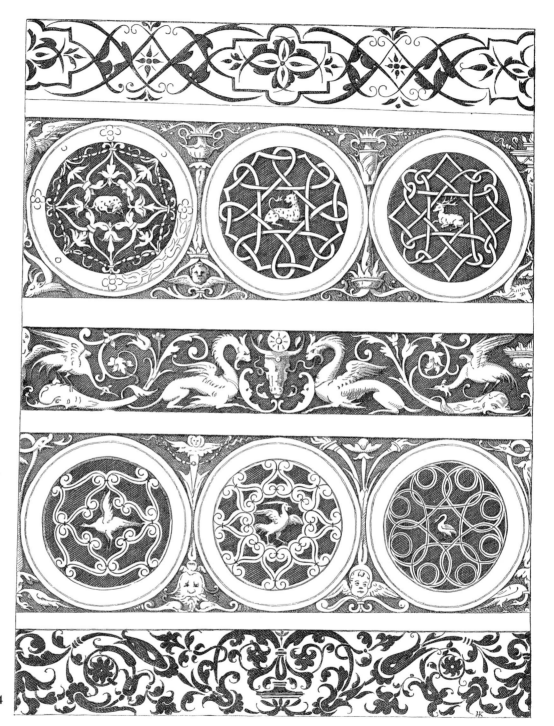

54-55:
Friezes, 16th century.
Frises, XVI^e siècle.
Fries, 16. Jh.
Фризы, 16 век.

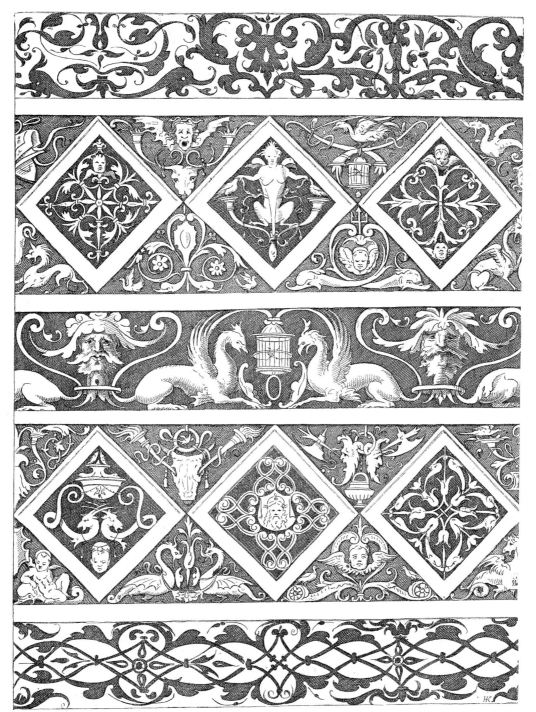

55

Cornelis Floris, Decorative
panel, The Nedernlands,
16th. century.
Cornelis Floris, Paneau
décoratif, Pays–Bas,
XVIᵉ siècle.
Cornelis Floris,
Schmucktafel, Niederlande,
16. Jh.
Корнелис Флорис,
Декоративная панель,
Нидерланды, 16 век.

56

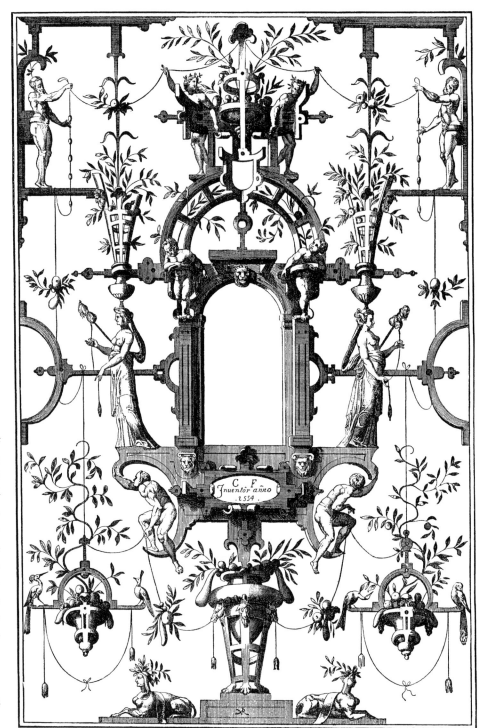

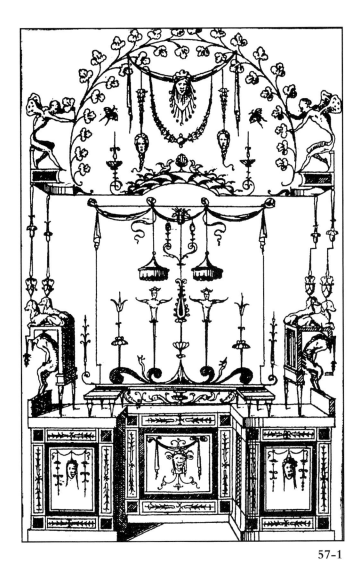

57-1

57-59:
Androuet du Cerceau, Grotesques, France, 1550.
Androuet du Cerceau, Grotesken, Frankreich, 1550.
Андруэ дю Серсо, Гротески, Франция, 1550.

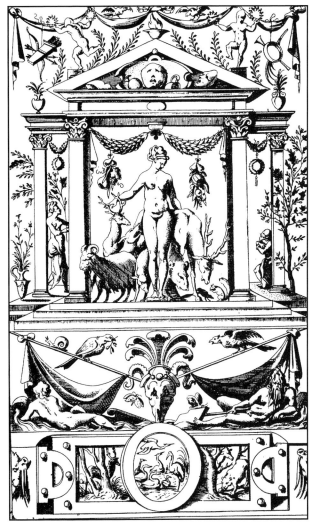

57-2

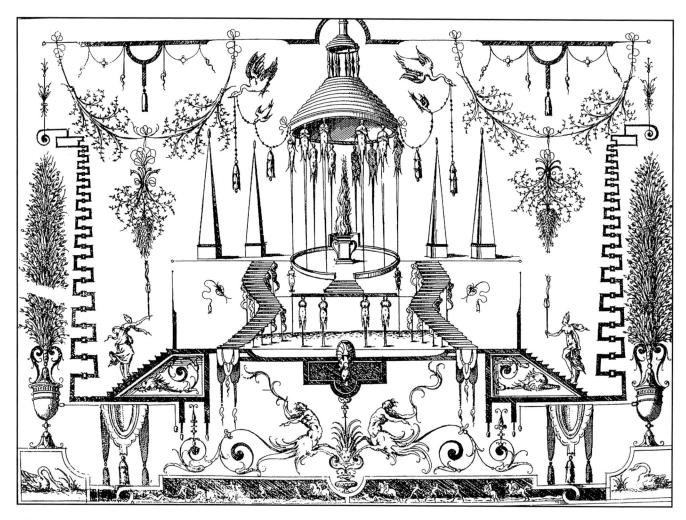

58

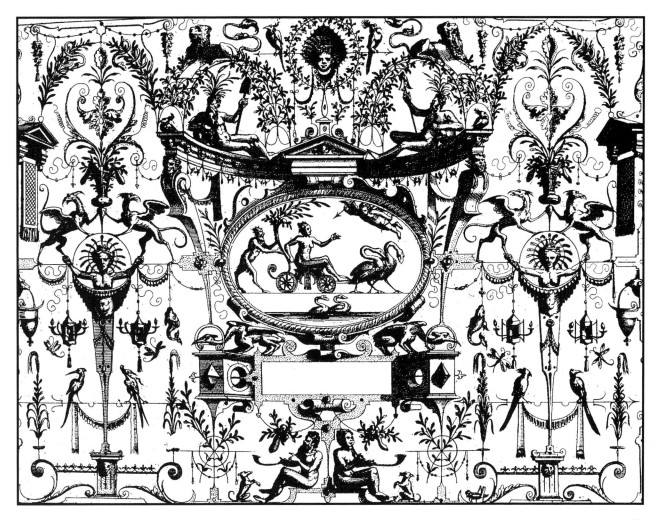

59

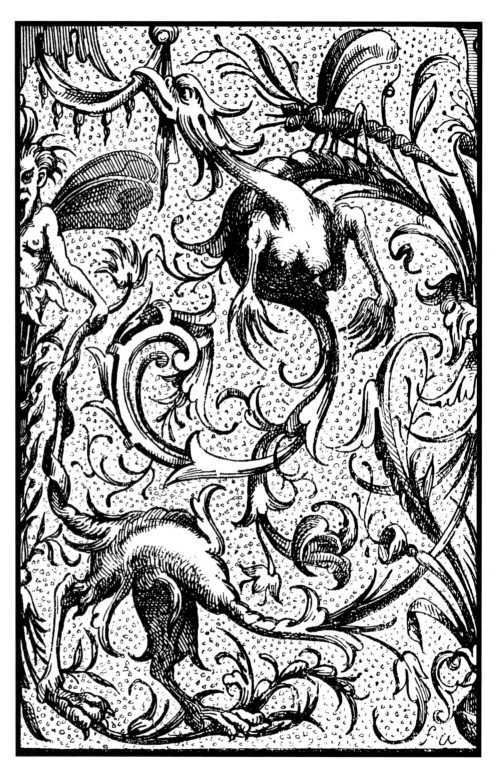

Grotesque, Antwerp,
16th century.
Grotesque, Anvers, XVIᵉ siècle.
Groteske, Antwerpen, 16. Jh.
Гротеск, Антверпен,
16 век.

60

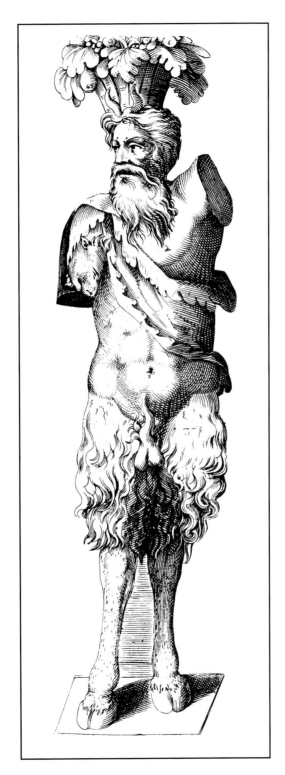

Grotesque, 16th century.
Grotesque, XVI^e siècle.
Groteske, 16. Jahrh.
Гротеск, 16 век.

61

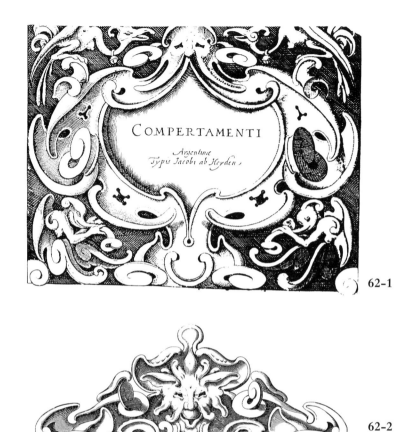

62-1

62-2

62-3

62-63:
Jacob ab Heyden. Grotesques, The Netherlands, 17th century.
Jacob ab Heyden. Grotesques, Pays–Bas, XVIIe siècle.
Jacob ab Heyden. Grotesken, Niederlande, 17th century.
Якоб аб Хейден. Гротески, Нидерланды, 17 век.

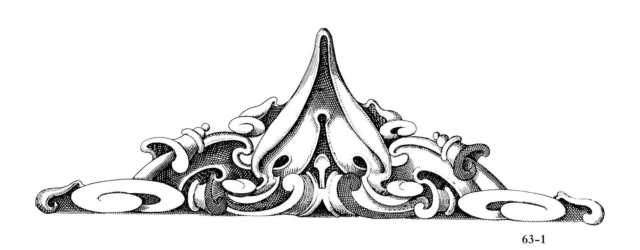

63-1

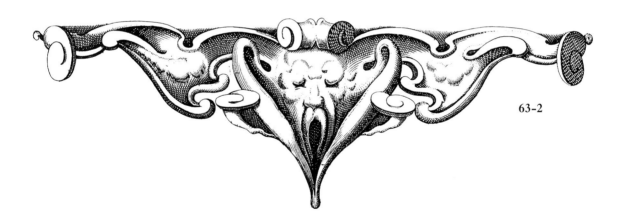

63-2

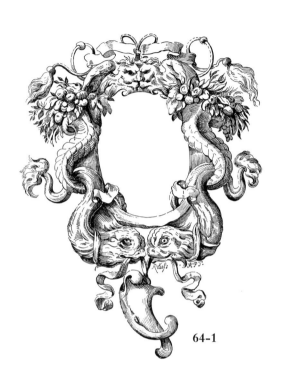

64-1

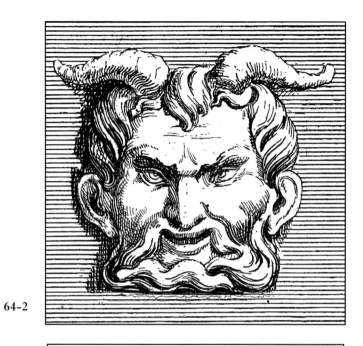

64-2

64-1; 65-1:
Cartouches, France, 16th century.
Cartouches, France, XVIᵉ siècle.
Patronen, Frankreich, 16. Jh.
Картуш, Франция, 16 век.

64-2; 64-3:
Masks, 16th century.
Masques, XVIᵉ siècle.
Maskarone, 16. Jh.
Маски, 16 век.

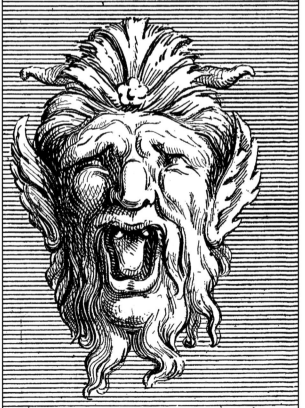

64-3

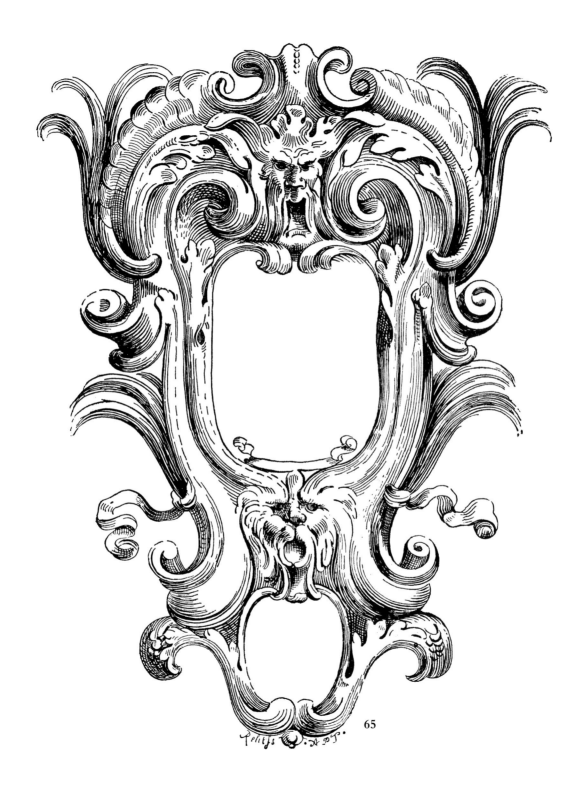

65

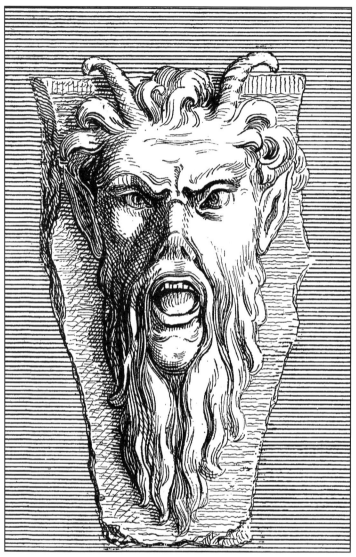

66-1

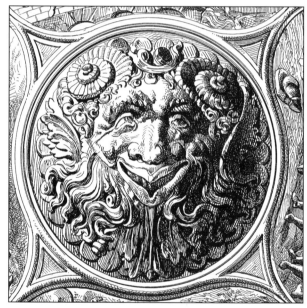

66-2

66-67:
Masks, 16th century.
Masques, XVIᵉ siècle.
Maskarone, 16. Jh.
Маски, 16 век.

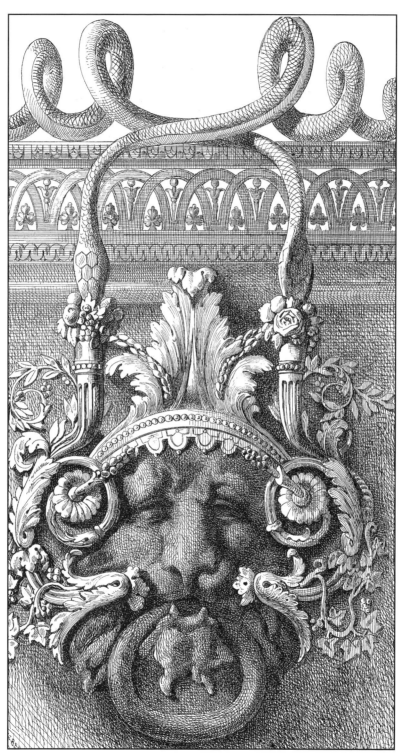

67

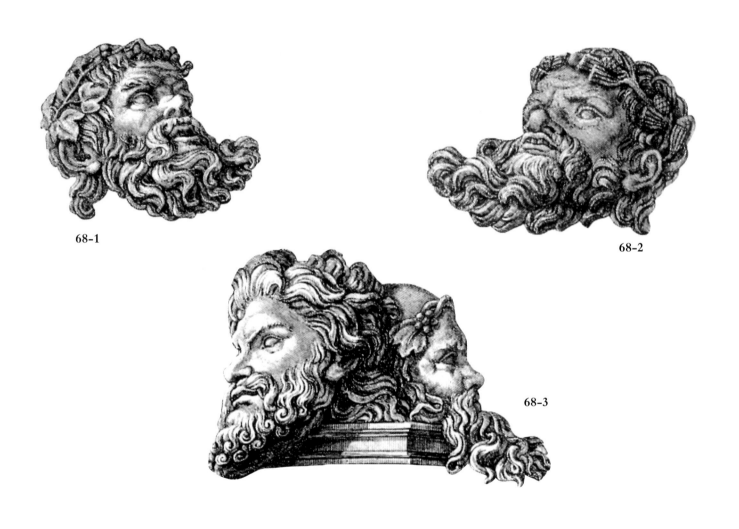

68-1

68-2

68-3

Piranese. *Vase, Candelabri, Cippi*, 1770-1778.

68

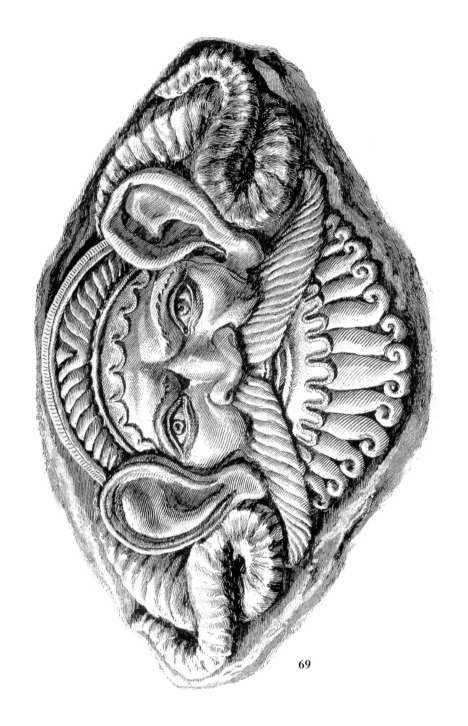

69

Piranese. *La Magnificenza*, 1769.

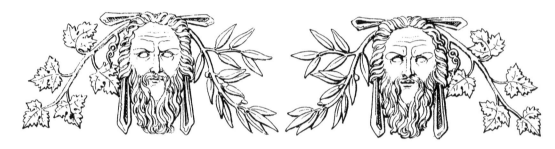

70-1

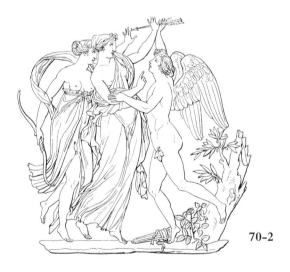

70-2

70-76:
*Recueil des dessins d'ornements
d'architecture de la Manufacture de Joseph Beugnat*, circa 1813.

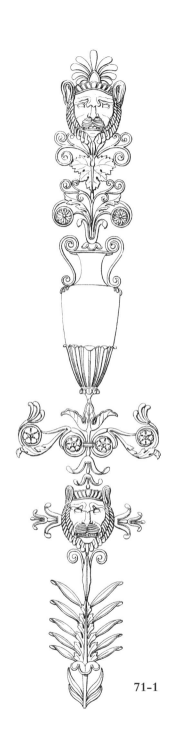

71-1

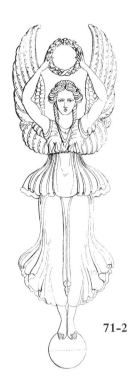

71-2

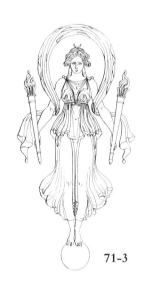

71-3

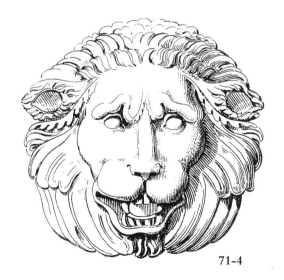

71-4

71

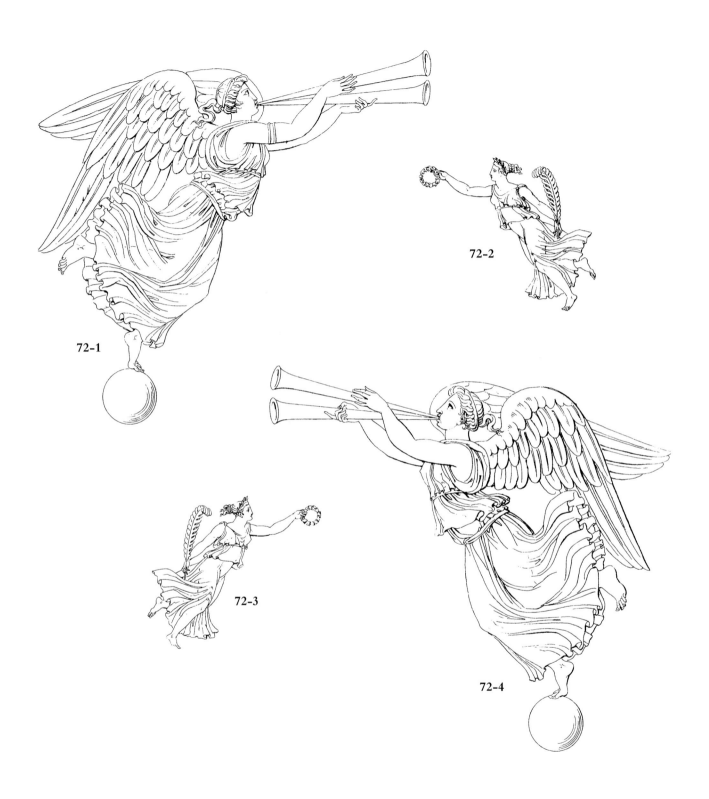

72-1

72-2

72-3

72-4

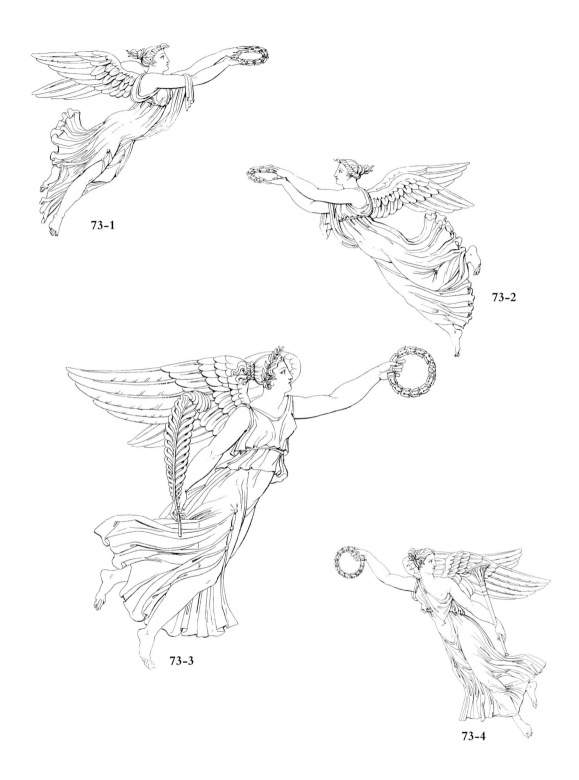

73-1

73-2

73-3

73-4

74-1

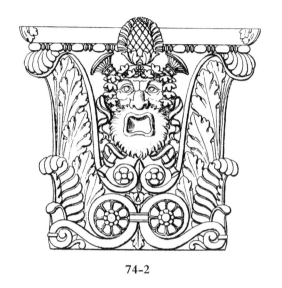

74-2

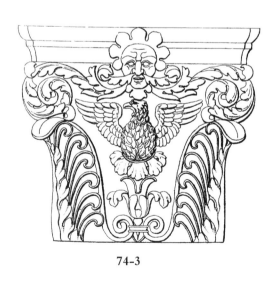

74-3

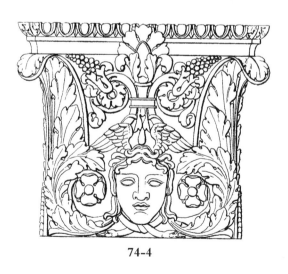

74-4

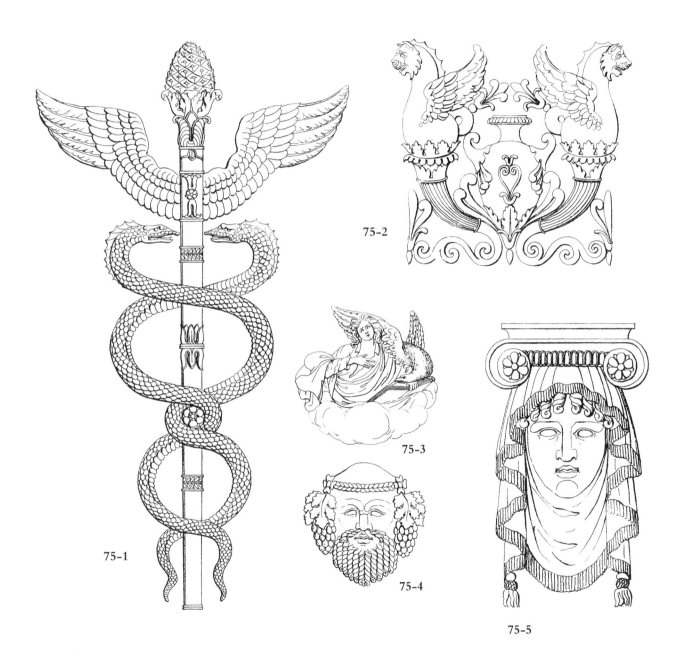

75-1

75-2

75-3

75-4

75-5

75

76-1

76-2

76-3

76-4

76-5

76-6

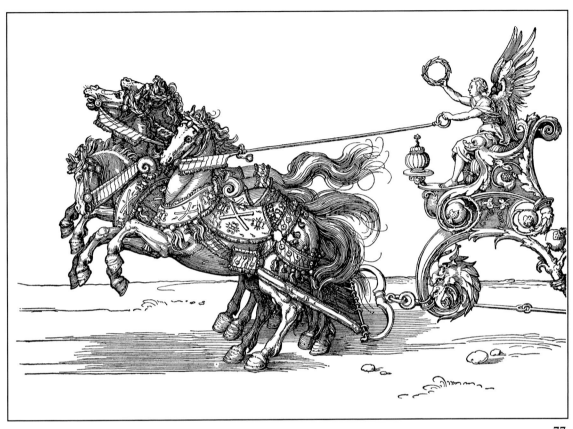

Albrecht Dürer. *Victory driving the Triumphal Chariot*, in
Les Noces bourguignones, 1526.
Albrecht Dürer. *La Victoire conduisant le char triomphal*,
in : *Les Noces bourguignones*, 1526.
Albrecht Dürer. *Der Sieg leitet den Triumphzug*, aus:
Burgundische Hochzeit, 1526.
Альбрехт Дюрер. Победа на триумфальной
колеснице, в кн. «Бургундские ночи», 1526.

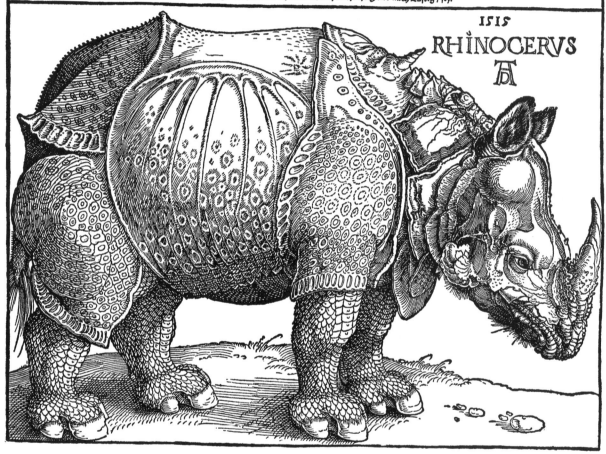

Albrecht Dürer. Rhinoceros, 1515.
Albrecht Dürer. Le Rhinocéros, 1515.
Albrecht Dürer. Das Nashorn, 1515.
Альбрехт Дюрер. Носороги, 1515.

79-1

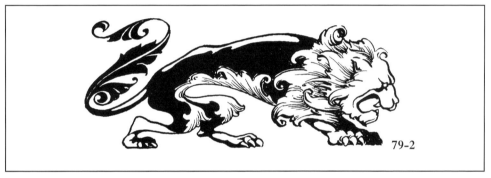

79-2

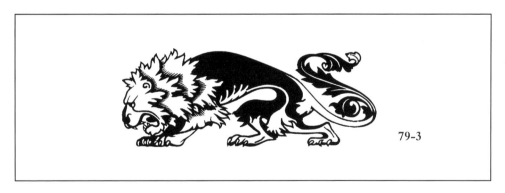

79-3

Typographic Vignettes, 19th century.
Vignettes typographiques, XIXᵉ siècle.
Typographische vignetten, 19. Jahrh.
Типографские виньетки, 19 век.

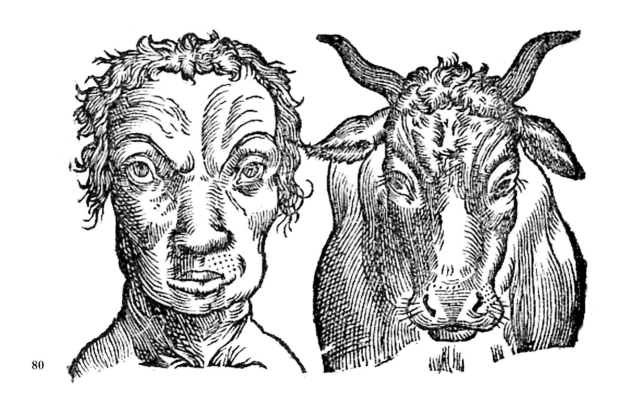

80-81:
Jean–Baptiste della Porta. *De Humana Phisiognomia*, 1650.

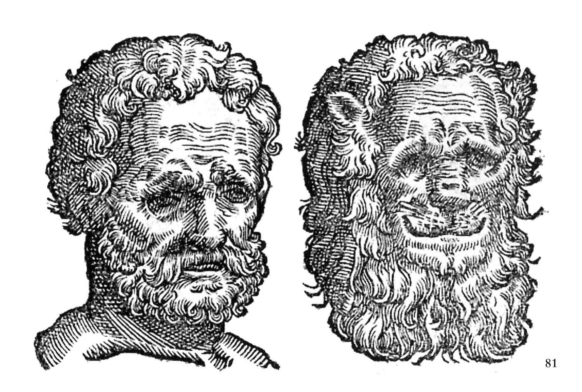

81

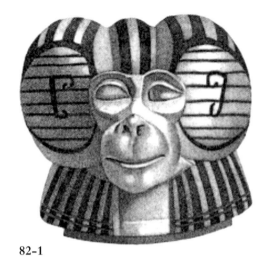

82-1

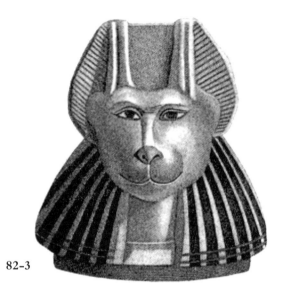

82-3

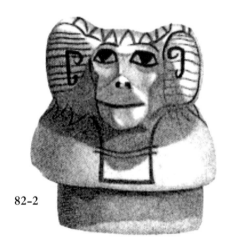

82-2

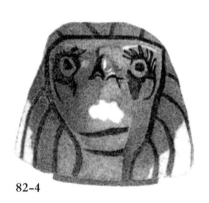

82-4

Egyptian figures, in *Description de l'Égypte,* Paris, 1809.
Figures égyptiennes, in : *Description de l'Égypte,* Paris, 1809.
Egyptische Figuren, aus: *Description de l'Égypte,* Paris, 1809.
Египетские фигурки, *Description de l'Égypte,* Paris, 1809.

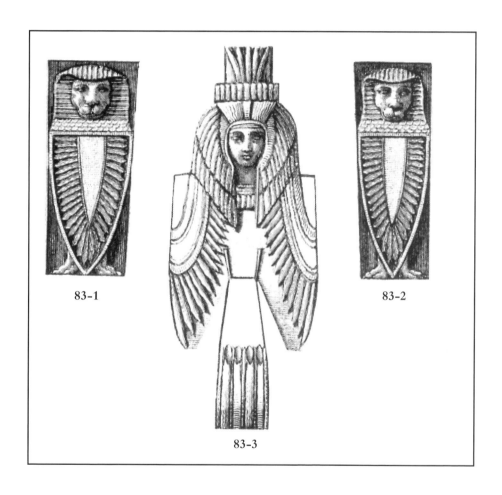

83-1

83-2

83-3

Piranese. *Diverse Maniere d'adornare i Cammini*, 1769.

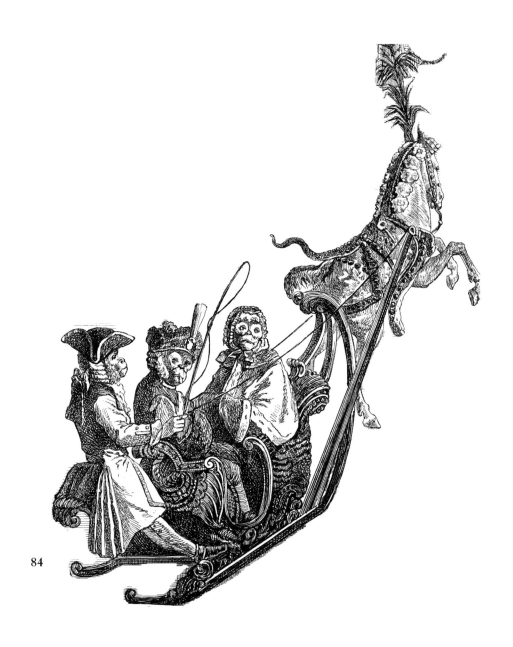

84

84-85:
Chinoiserie, 18th century.
Chinoiserie, XVIIIᵉ siècle.
Chinoiserien, 18. Jahrh.
Китайский стиль, 18 век.

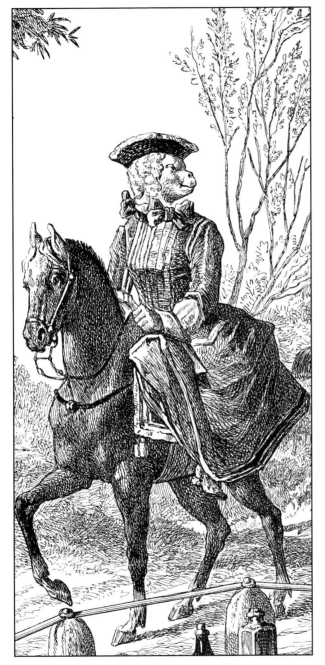

85-1

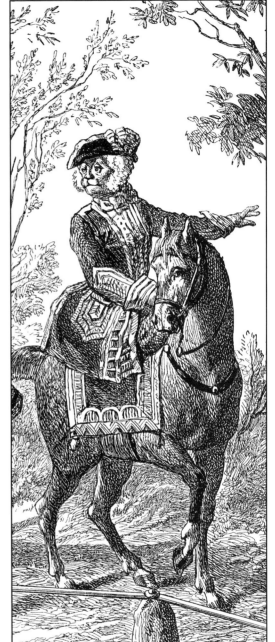

85-2

85

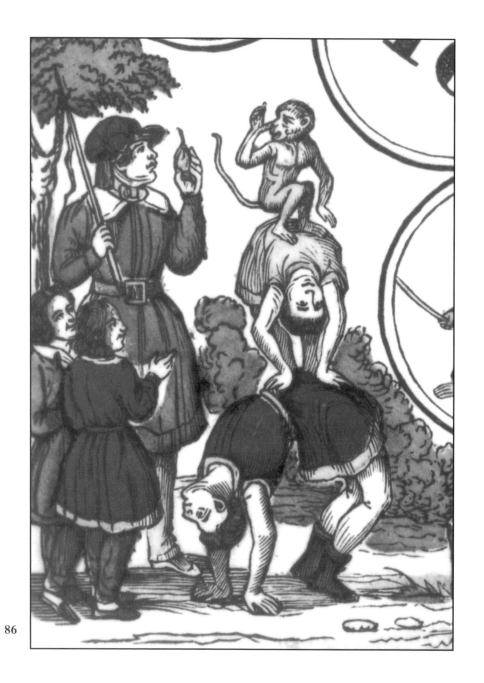

Nouveau jeu des singes, France, 19th century.

87-1

87-3

87-2

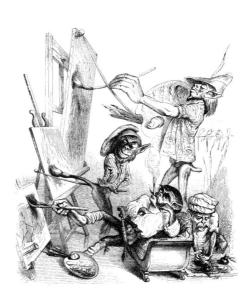

87-4

Gustave Doré. *Illustrations,* Paris, 19th century.
Gustave Doré. *Illustrations,* Paris, XIXe siècle.
Gustave Doré. *Illustrationen,* Paris, 19. Jahrh.
Гюстав Дорэ. Иллюстрации, Париж, 19 век.

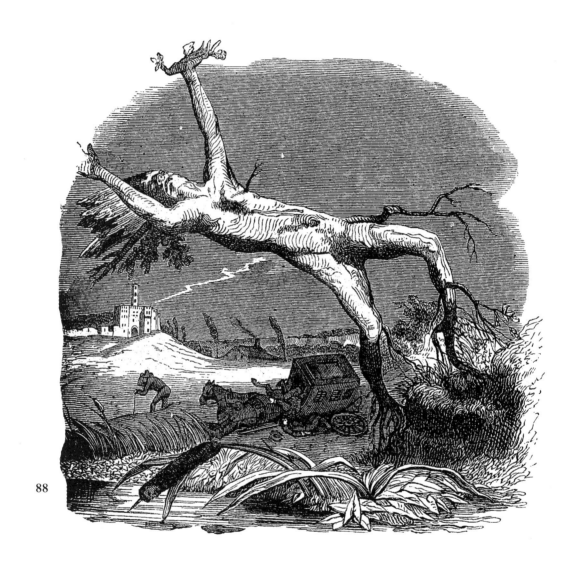

88

88–89:
Grandville. *Les Fables de La Fontaine,* Paris, 1838.

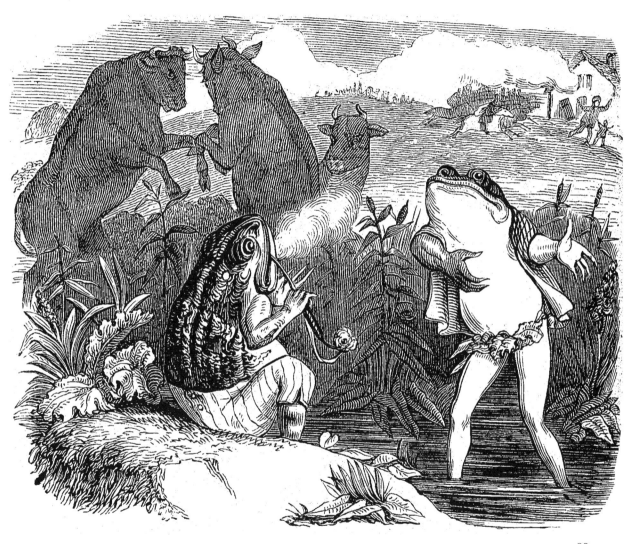

89

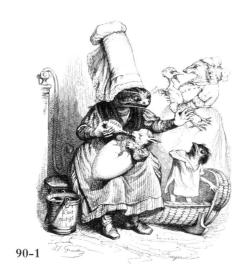

90-1

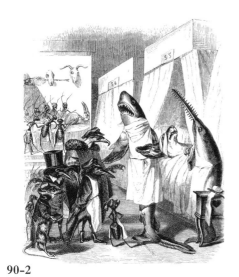

90-2

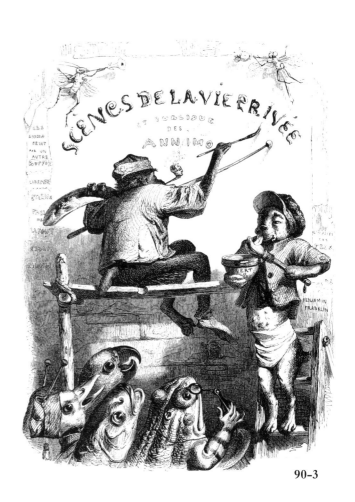

90-3

90-110:
Grandville. *Scènes de la vie privée et publique des animaux*, Paris, 1841-1842.

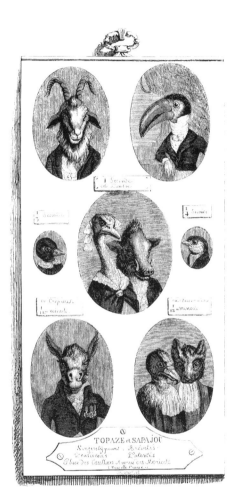
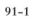

91-1

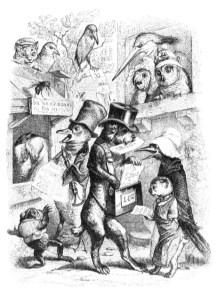

91-2

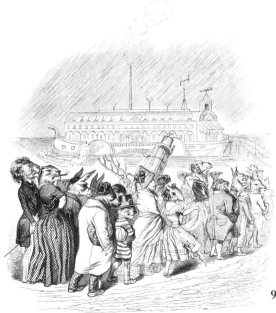

91-3

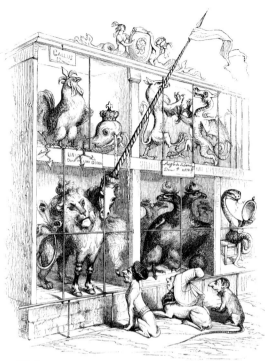

92-1

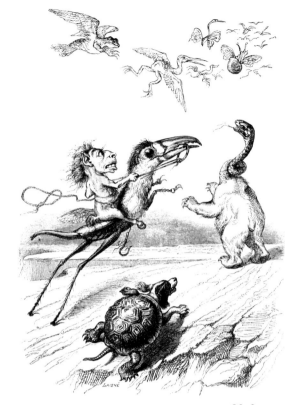

92-3

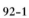
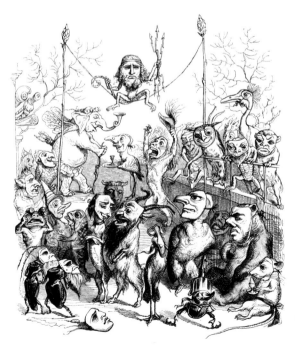

92-2

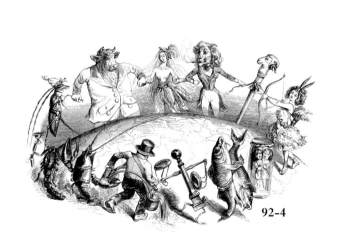

92-4

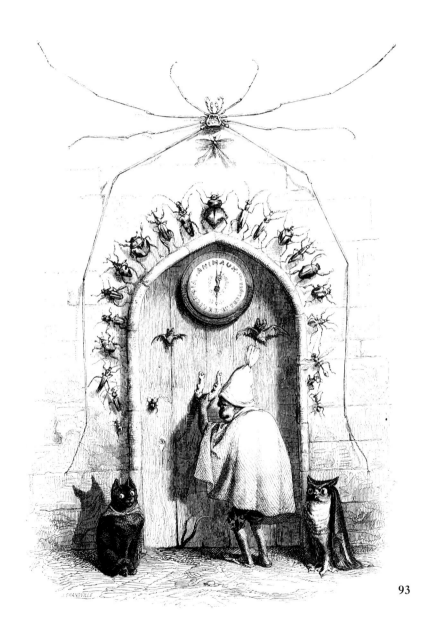

93

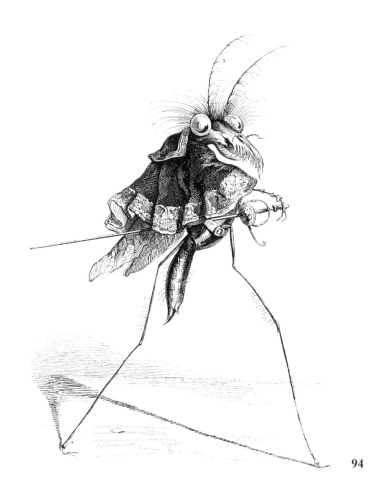

94

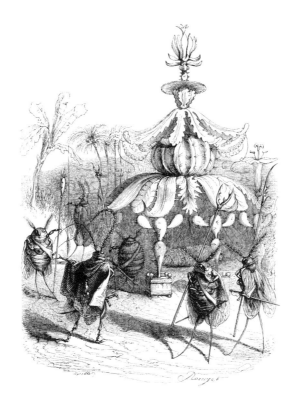

95-1

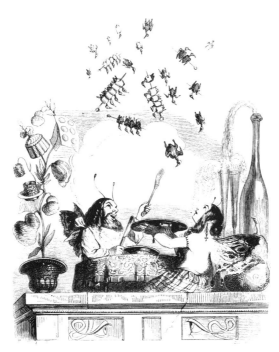

95-2

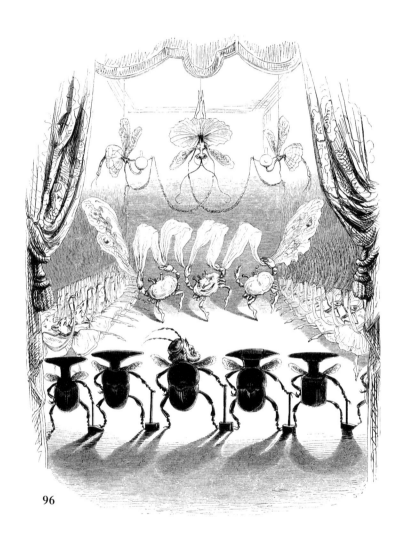

96

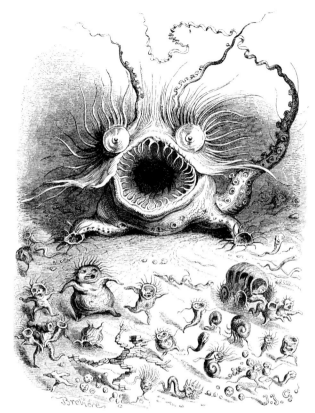

97-1

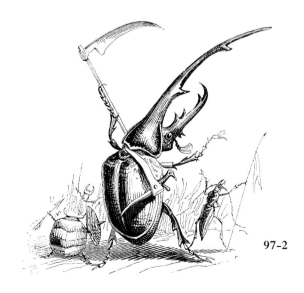

97-2

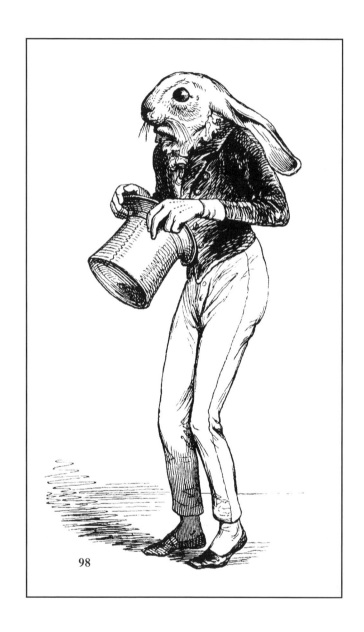

98

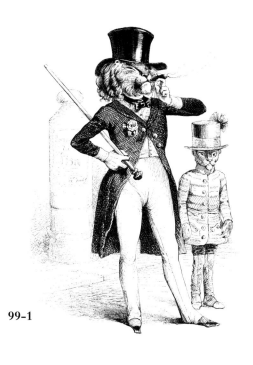

99-1

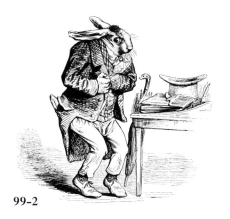

99-2

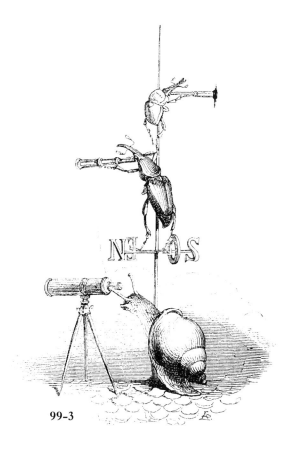

99-3

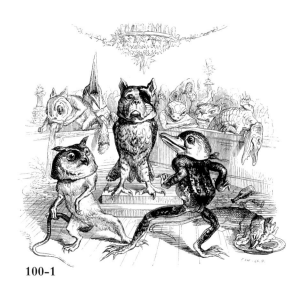

100-1

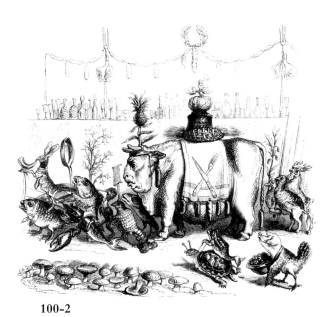

100-2

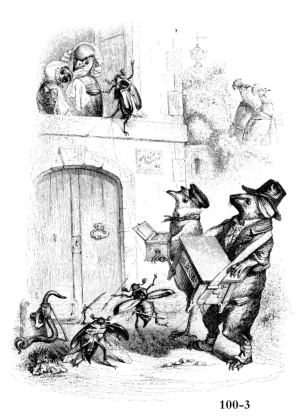

100-3

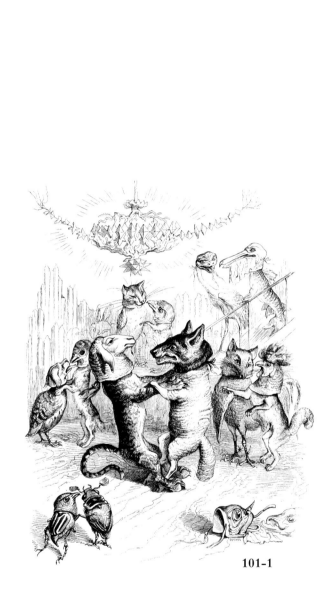

101-1

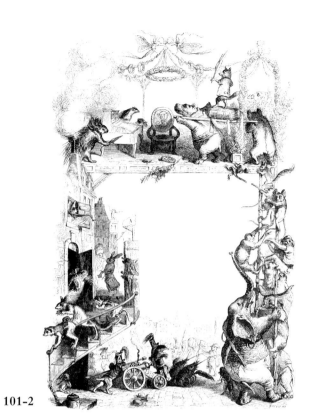

101-2

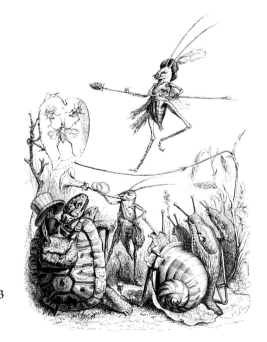

101-3

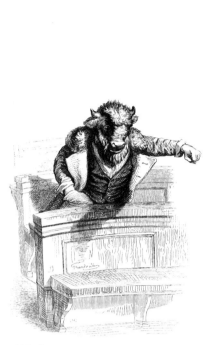

102-1

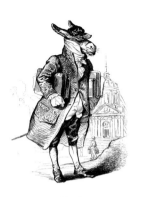

102-2

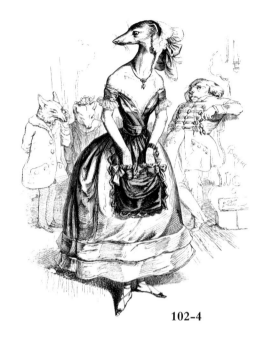

102-4

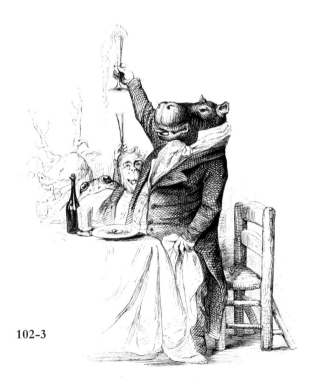

102-3

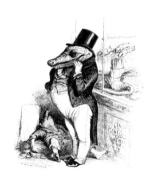

102-5

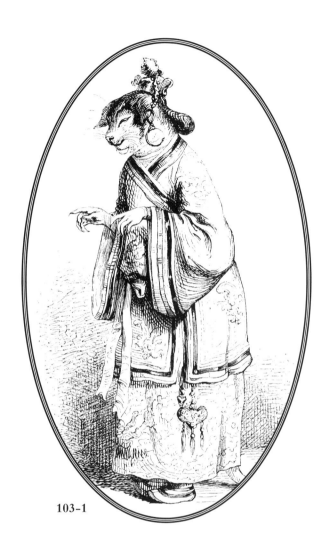

103-1

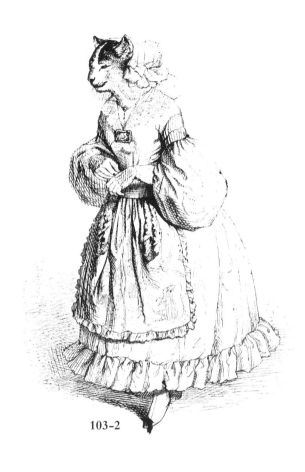

103-2

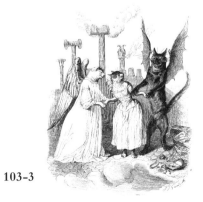

103-3

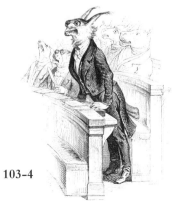

103-4

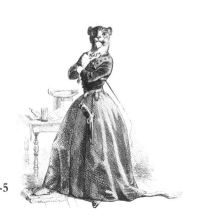

103-5

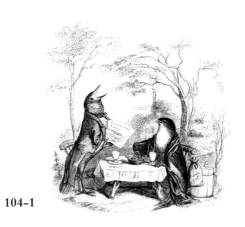

104-1

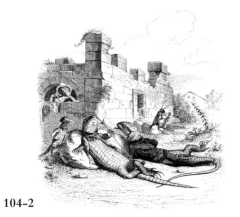

104-2

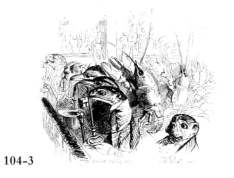

104-3

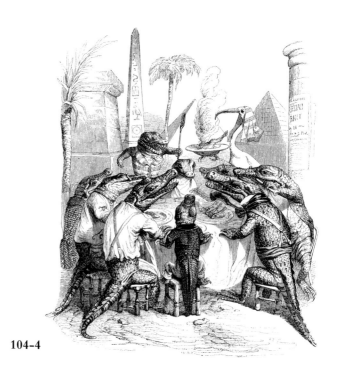

104-4

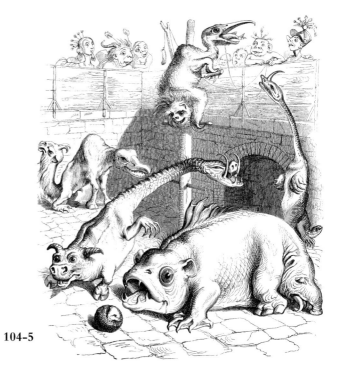

104-5

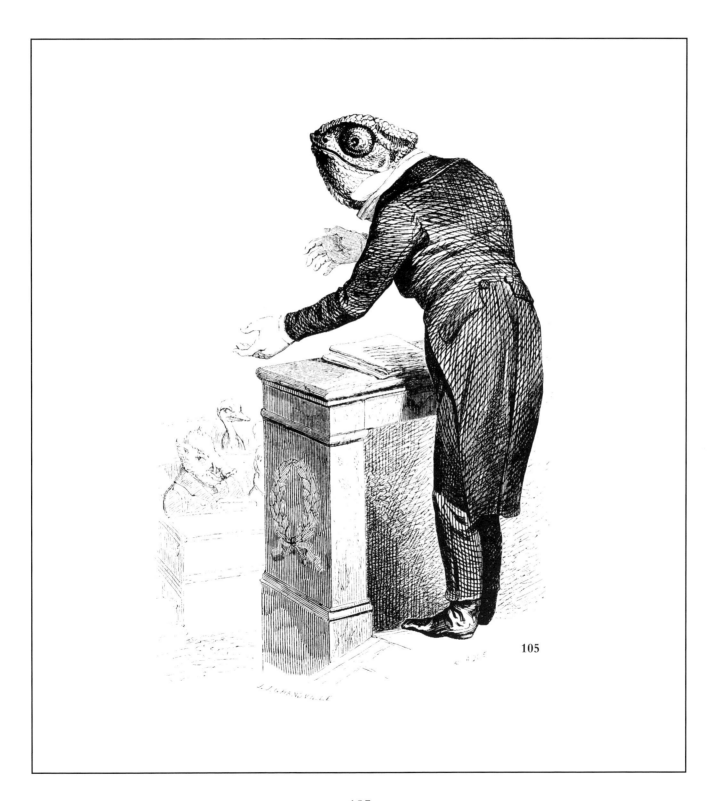

105

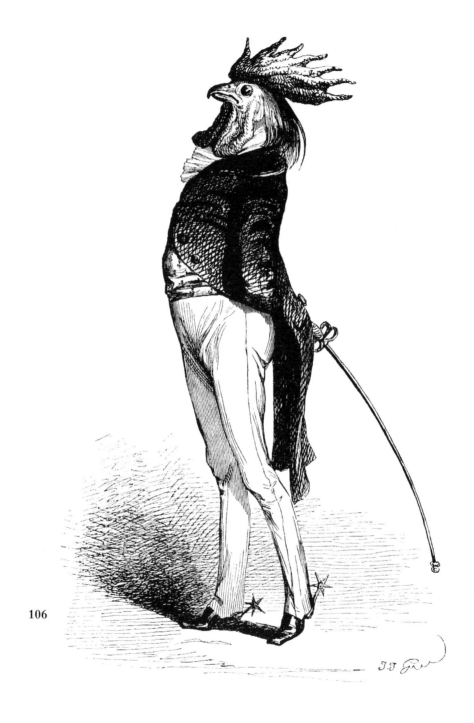

106

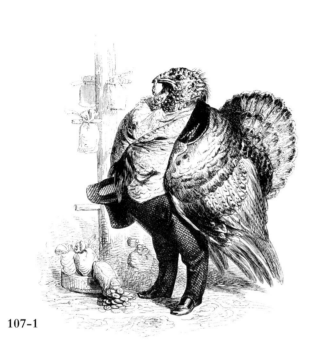

107-1

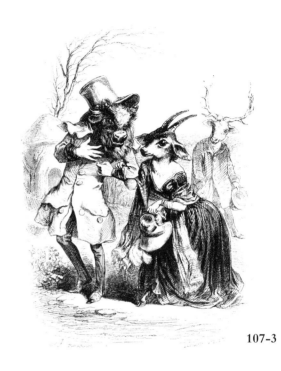

107-3

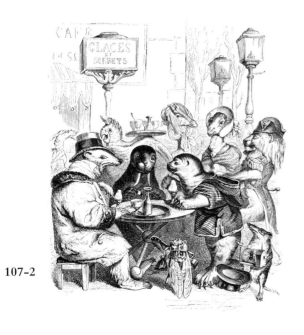

107-2

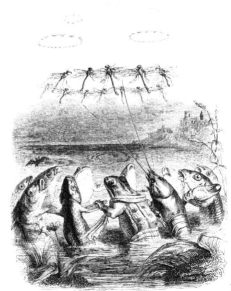

107-4

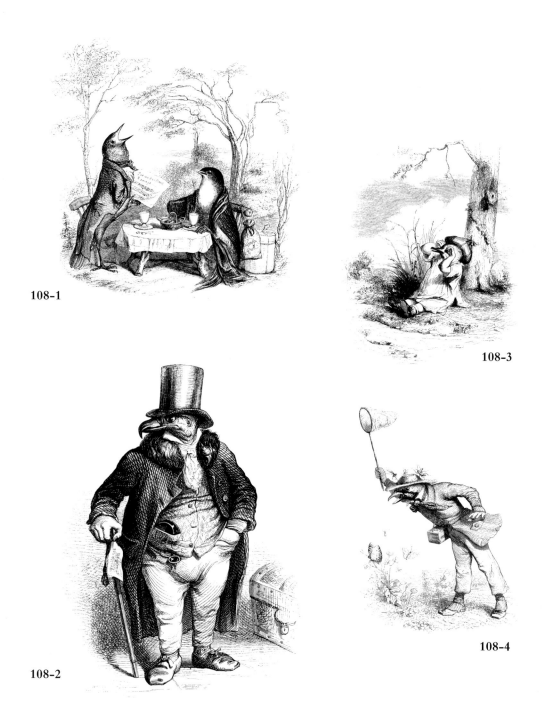

108-1

108-3

108-2

108-4

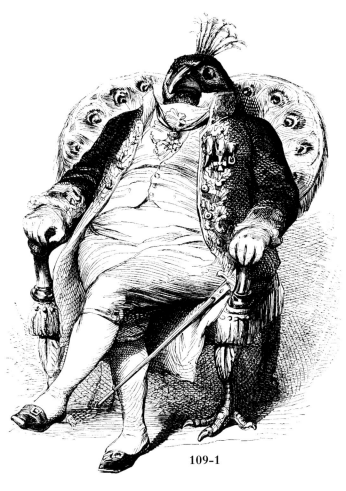

109-1

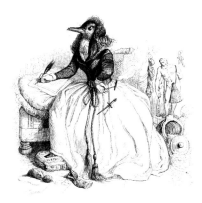

109-2

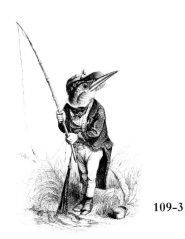

109-3

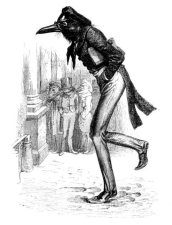

109-4

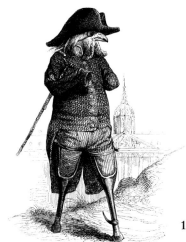

109-5

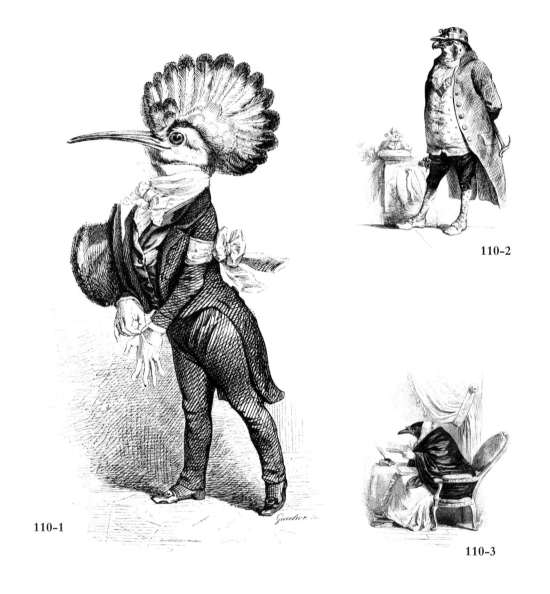

110-1

110-2

110-3

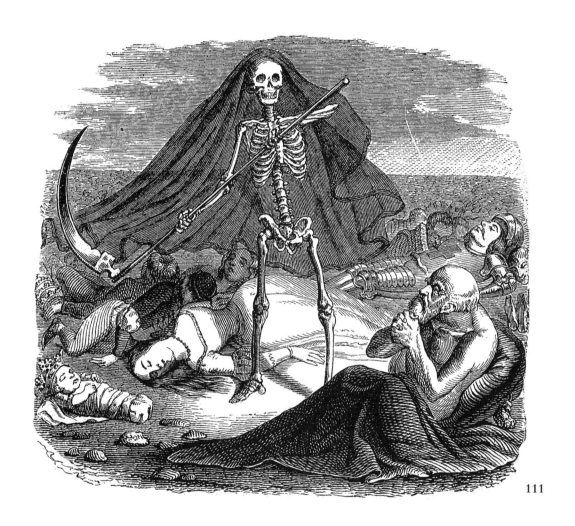

111

Grandville. *Les Fables de La Fontaine*, 1838.

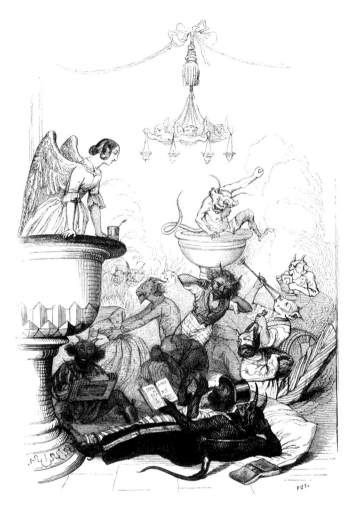

112-1

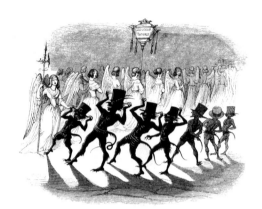

112-2

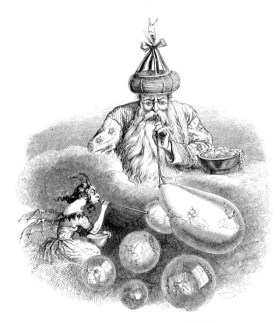

112-3

Granville. Illustrations, 19th century.
Grandville. Illustrations, XIX⁰ siècle.
Grandville. Illustrationen, 19. Jahrh.
Гранвилль. Иллюстрации, 19 век.

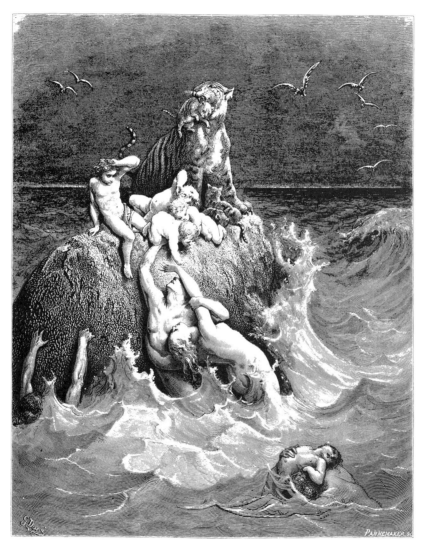

113

Gustave Doré. The Deluge, in *The Bible*, Paris, 19th century.
Gustave Doré. Le Déluge, in: *La Bible*, Paris, XIXᵉ siècle.
Gustave Doré. Noah schickt eine Taube auf Land, aus: *Die Bibel*, Paris, 19. Jahrh.
Гюстав Дорэ. Библейский Потоп, Париж, 19 век

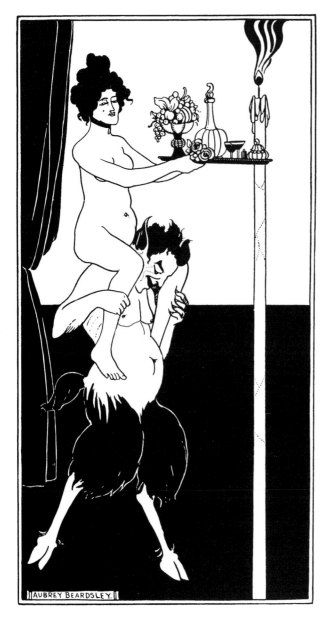

114-1

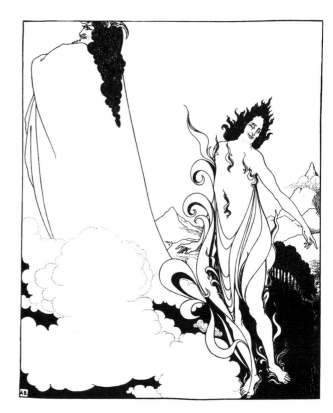

114-2

114-117:
Aubrey Beardsley. Illustration, 19th century.
Aubrey Beardsley. Illustration, XIXᵉ siècle.
Aubrey Beardsley. Illustration, 19. Jahrh.
Обри Бердсли. Иллюстрация, 19 век.

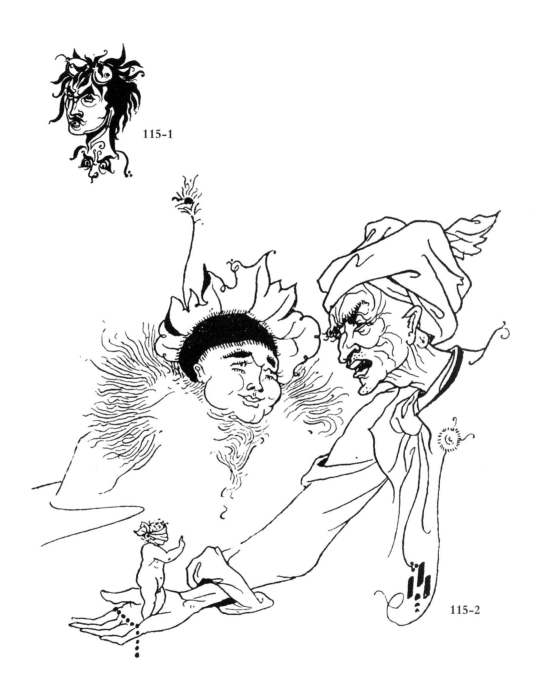

115-1

115-2

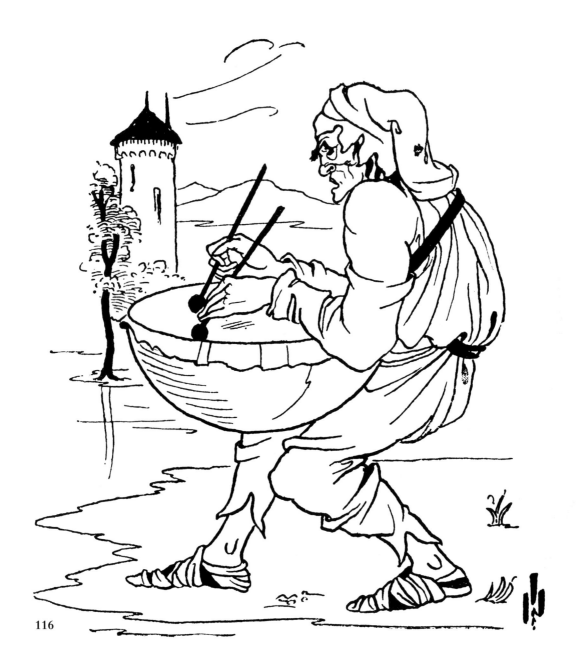

116

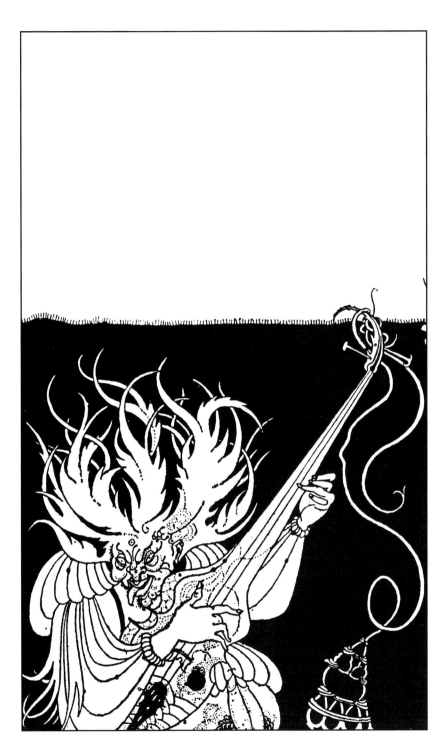

117-1

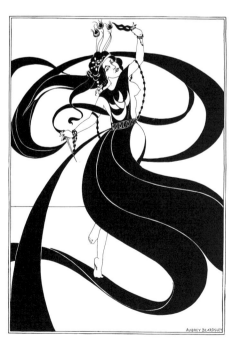

117-2

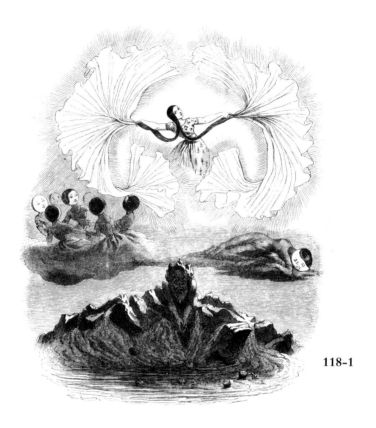

118-1

118-123:
Granville. Illustrations, 19th century.
Grandville. Illustrations, XIX^e siècle.
Grandville. Illustrationen, 19. Jahrh.
Гранвилль. Иллюстрации, 19 век.

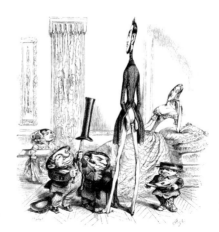

118-2

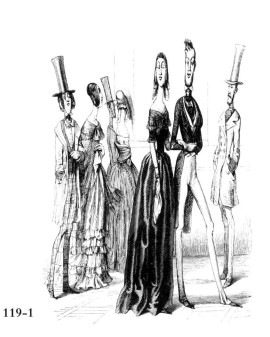

119-1

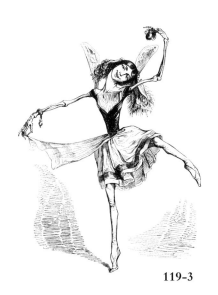

119-3

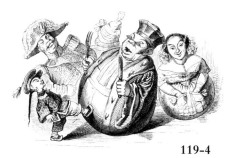

119-4

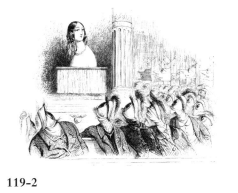

119-2

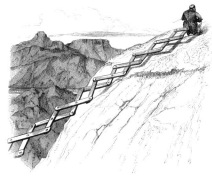

119-5

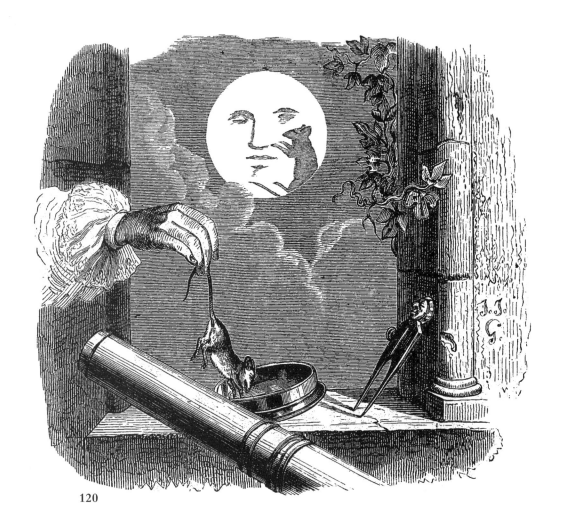

120

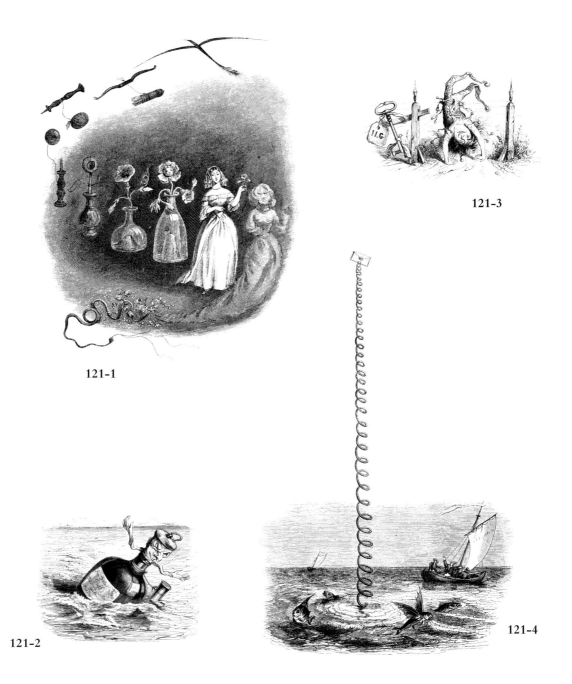

121-1

121-2

121-3

121-4

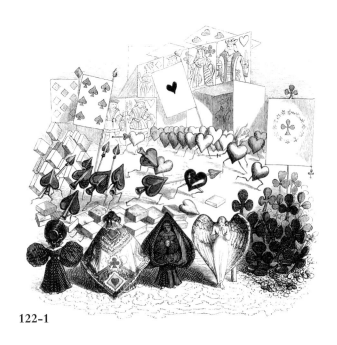

122-1

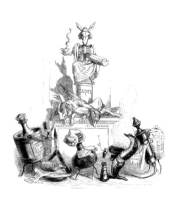

122-3

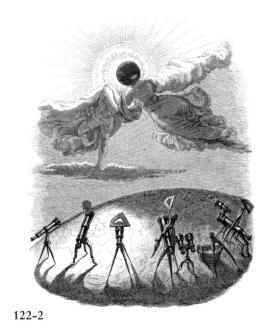

122-2

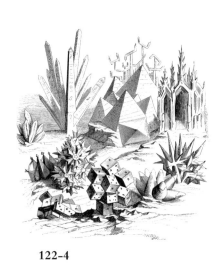

122-4

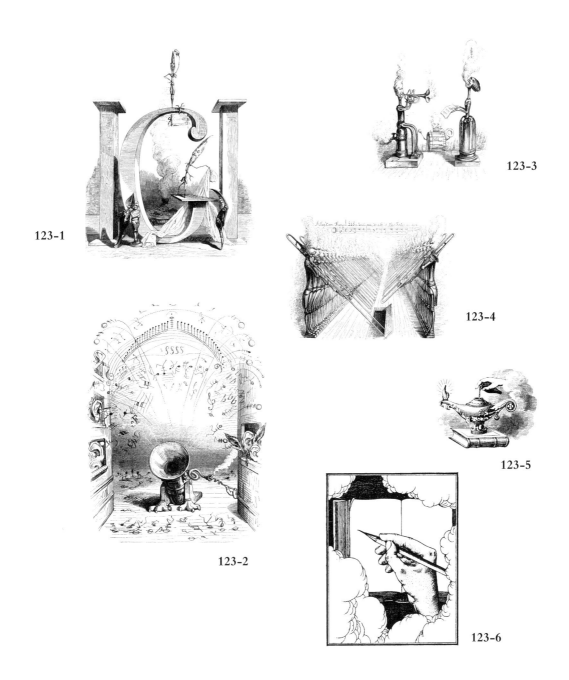

123-1

123-2

123-3

123-4

123-5

123-6

Borders • Bordures Borduren • Бордюры

Renaissance Ornaments • Ornements Renaissance • Renaissance Ornamente Орнаменты Ренессанса

Arabic Ornament • Ornement árabe Ornamentación árabe • Arabische Ornamente

Floral Ornament Ornement Floral Blumen Ornamente Ornamentación Floral Цветочный Орнамент

Art Nouveau Ornament Ornement Art nouveau Jugendstil Ornamente Ornamentación Arte nuevo Арт Нуво Орнаменты

Ironwork • Fer forgé Schmiedeeisen • Hierro forjado Изделия из металла

Typographic Decoration Décor typographique Typographische Muster Decoración tipográfica Типографский декор

Alphabets Alphabete Alfabetos Алфавиты

Furniture Mobilier Mobiliar Mobiliario Мебель

Chinese Ornament Ornement chinois Chinesische Ornamente Ornamentación china Китайский орнамент

Egyptian Ornament Ornement égyptien Ägyptische Ornamente Ornamentación egipcia Египетский орнамент

Japanese Ornament Ornement japonais Japanische Ornamente Ornamentación japonés Японский орнамент

Achevé d'imprimer en Slovaquie
en mars 2007
Dépôt légal 1er trimestre 2007